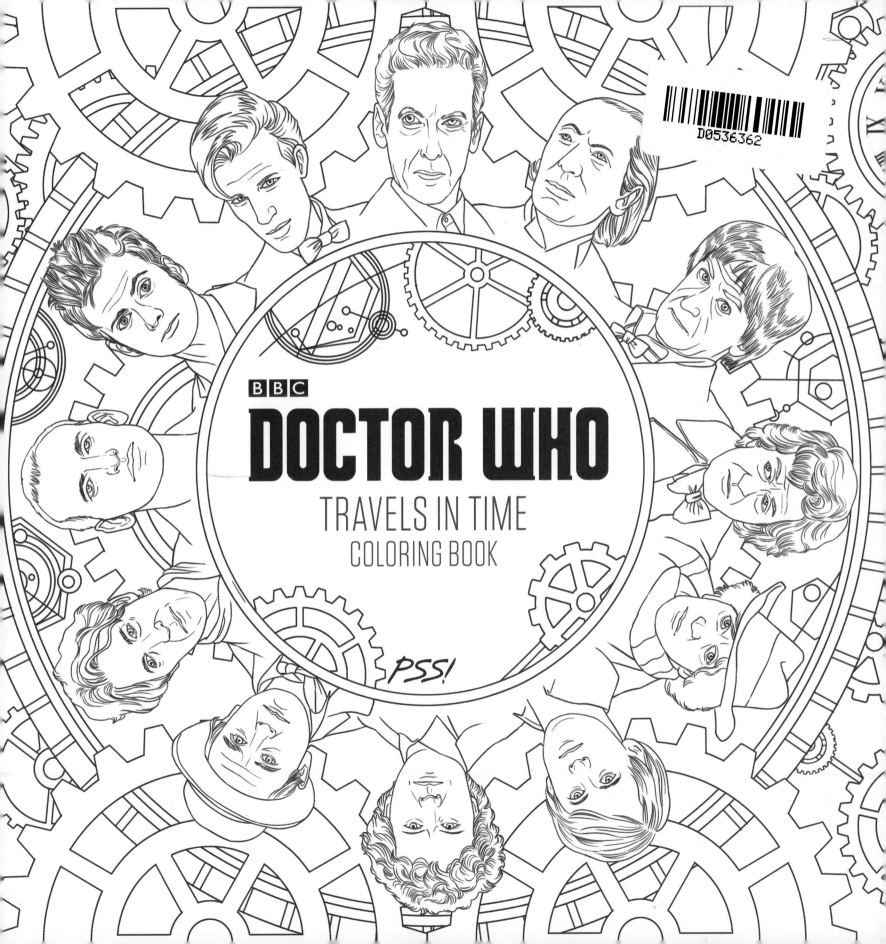

BBC

DOCTOR WHO

TRAVELS IN TIME
COLORING BOOK

PSS!

PRICE STERN SLOAN

An Imprint of Penguin Random House LLC

First published in the United Kingdom in 2016 by Puffin Books. First published in the United States of America in 2016 by Price Stern Sloan, an imprint of Penguin Random House LLC, 345 Hudson Street, New York, New York 10014. *PSS!* is a registered trademark of Penguin Random House LLC. Manufactured in China.

ISBN 9780451534255 10 9 8 7 6 5 4 3 2 1

THIS BOOK BELONGS TO

Abby G.

THINGS TO FIND WITHIN TIME AND SPACE...

The Meddling Monk

Venetian mask

Cactus

Torch

Thistle

Burning skull

The Tower of London

Koh-i-noor diamond

Dalek

Scottish flag

Telephone

Frank Sinatra

THIS IS ONE CORNER OF ONE COUNTRY, IN ONE CONTINENT,
ON ONE PLANET, THAT'S A CORNER OF A GALAXY, THAT'S A CORNER
OF A UNIVERSE THAT IS FOREVER GROWING AND SHRINKING
AND CREATING AND DESTROYING AND NEVER REMAINING
THE SAME FOR A SINGLE MILLISECOND.

AND THERE IS SO, SO MUCH TO SEE.

Turn the page to begin a colouring adventure through time, with famous
figures and moments from throughout all of human history. Plus, of course,
a certain madman with a box . . .

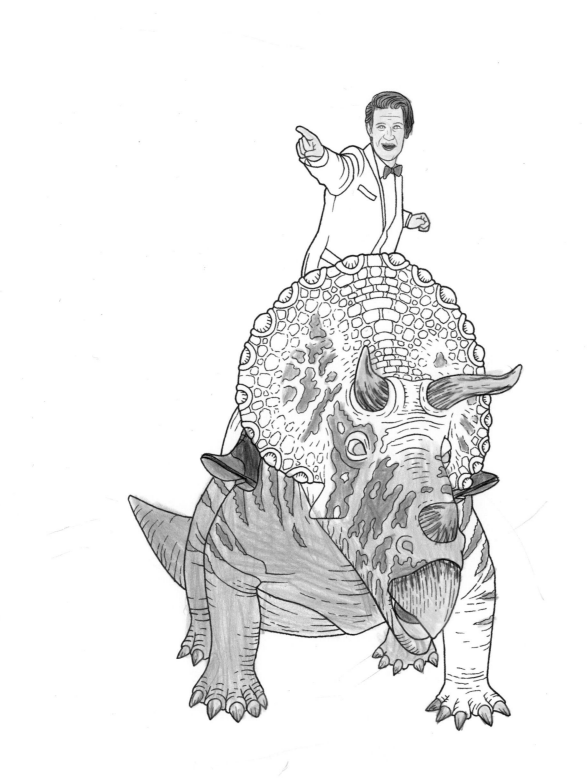

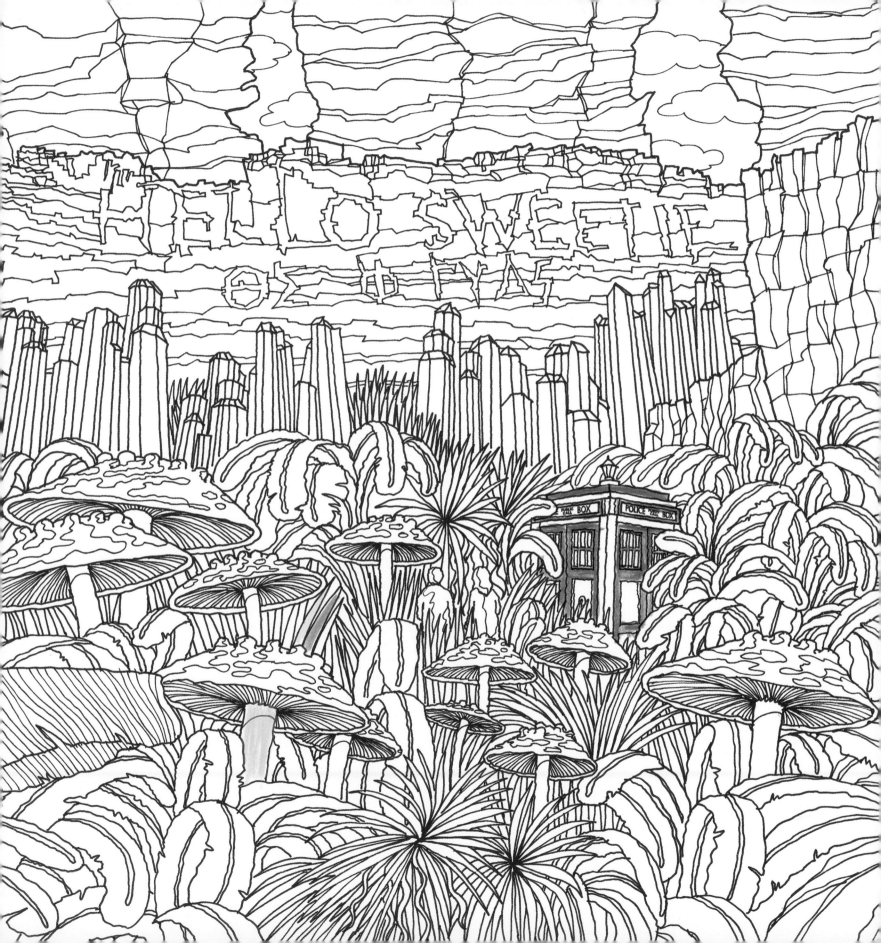

13 798 000 000 BC

Letters fifty feet high. A message from the dawn of time. And no one knows what it says, because no one's ever translated it.

The Eleventh Doctor, 'The Pandorica Opens', 2010

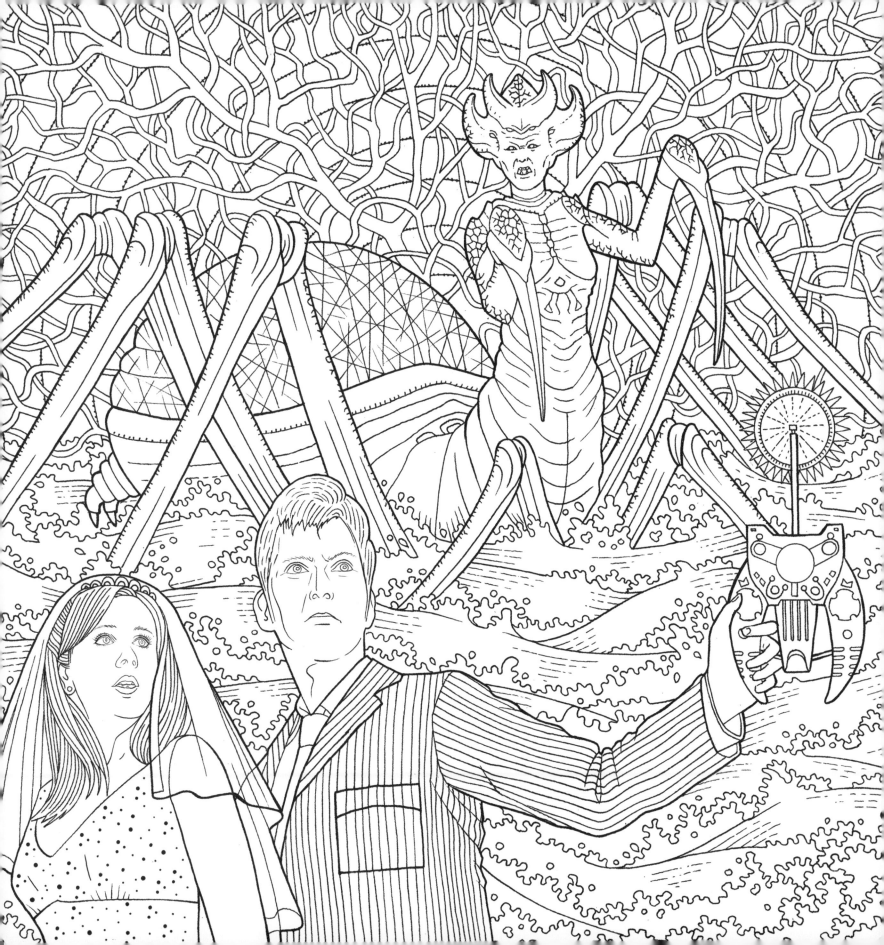

4 600 000 000 BC

They didn't just bury something at the centre of the Earth. They became the centre of the Earth.

The Tenth Doctor, 'The Runaway Bride', 2006

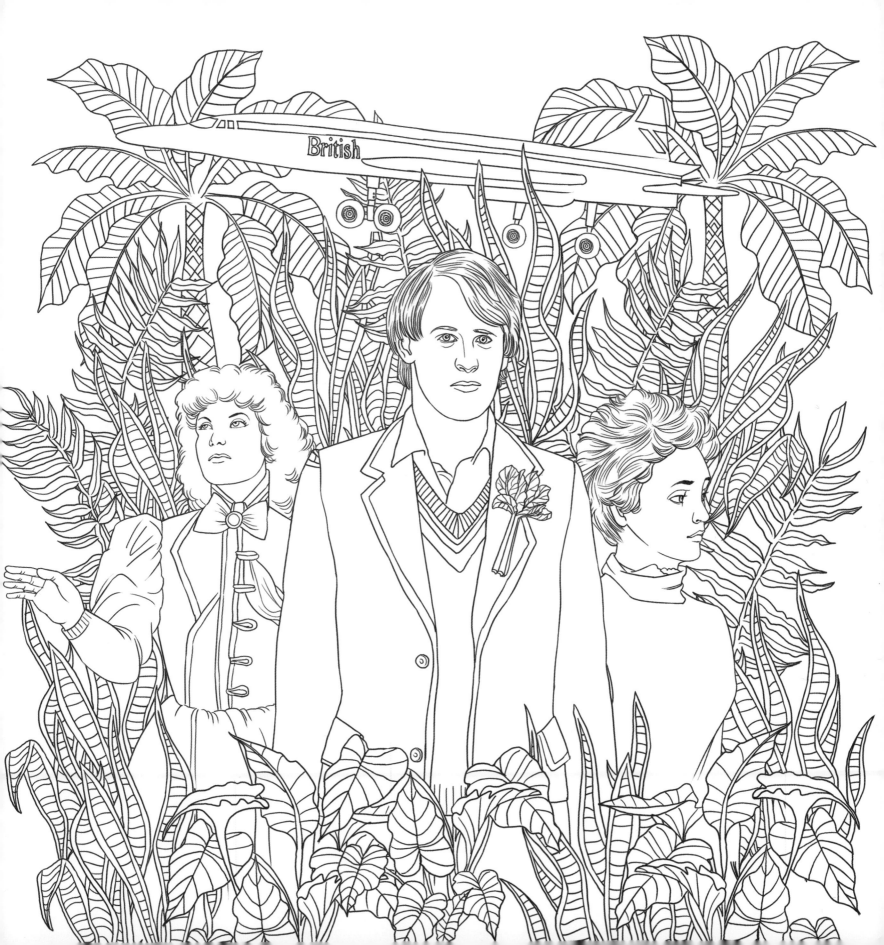

140 000 000 BC

Definitely Jurassic. There's a nip in the air, though. We can't be far off the Pleistocene era.

The Fifth Doctor, 'Time-Flight', 1982

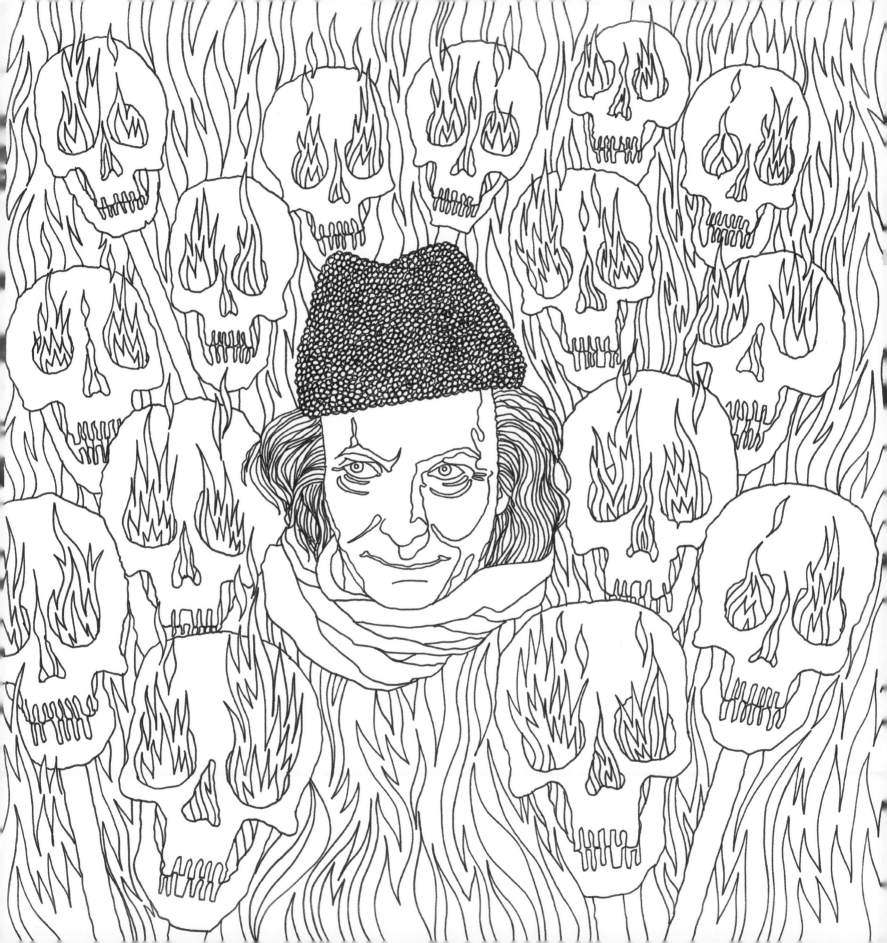

100 000 BC

If you could touch the alien sand and hear the cries of strange birds and watch them wheel in another sky, would that satisfy you?

The First Doctor, 'The Cave of Skulls', 1963

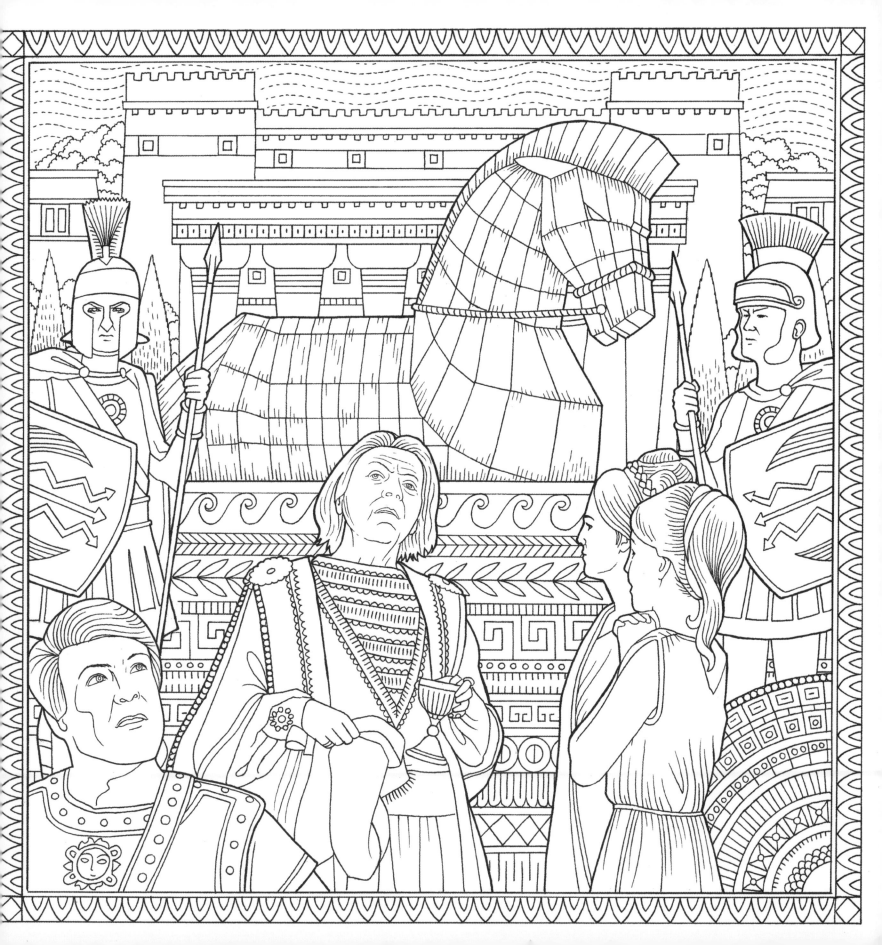

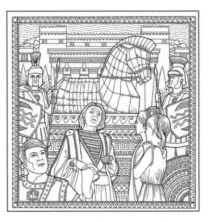

1193 BC

If I am not a god, how do you account for my supernatural knowledge?

The First Doctor, 'Temple of Secrets', 1965

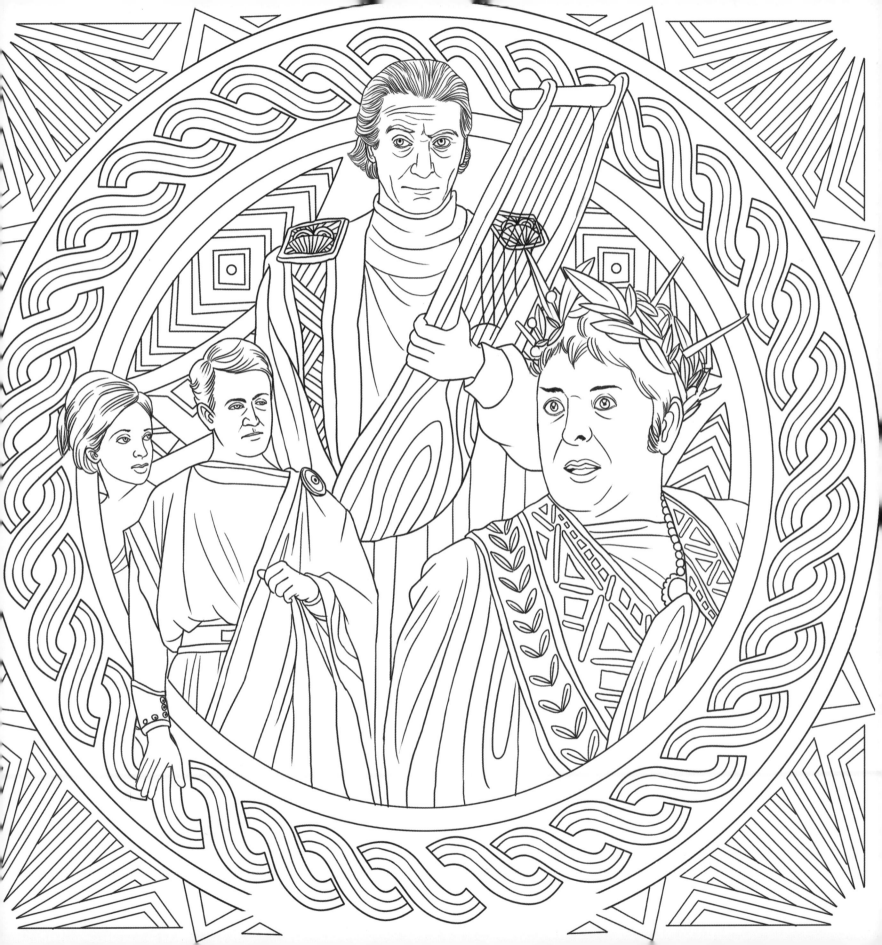

64 AD

There's one thing you've got to learn about me. When I say we go to Rome, then we go to Rome. Goodnight.

The First Doctor, 'The Romans', 1965

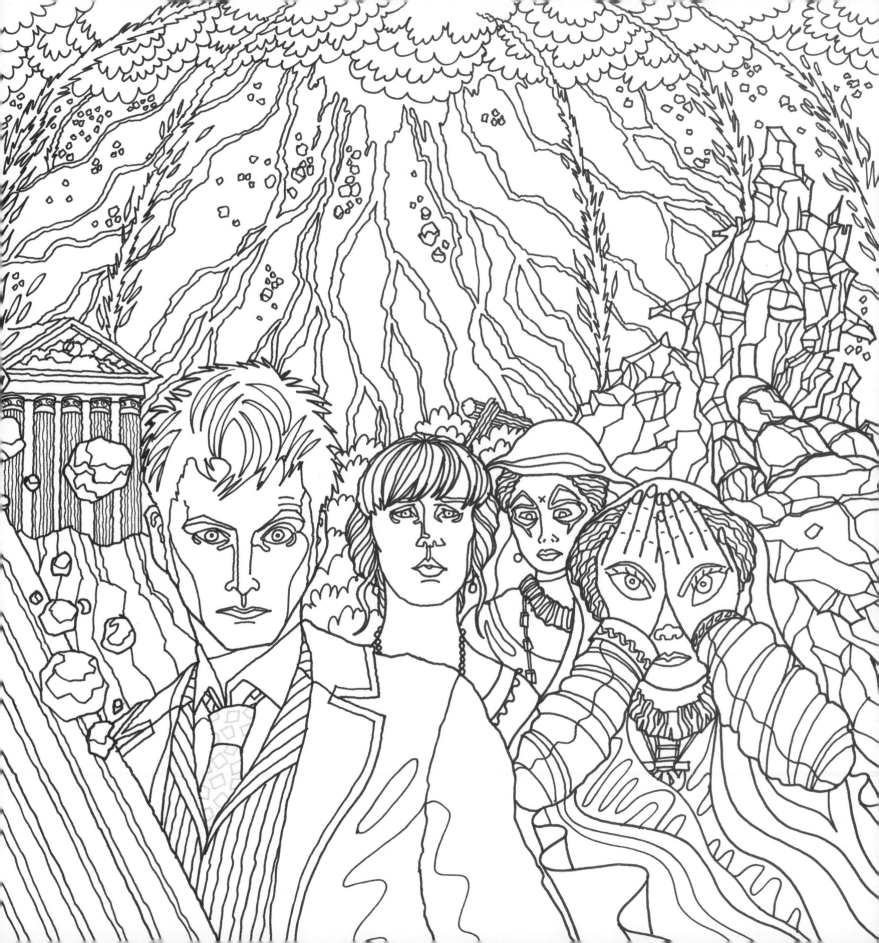

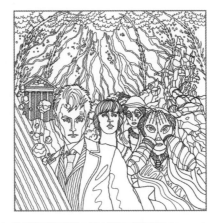

79 AD

Just someone. Please. Not the whole town. Just save someone.

Donna Noble, 'The Fires of Pompeii', 2008

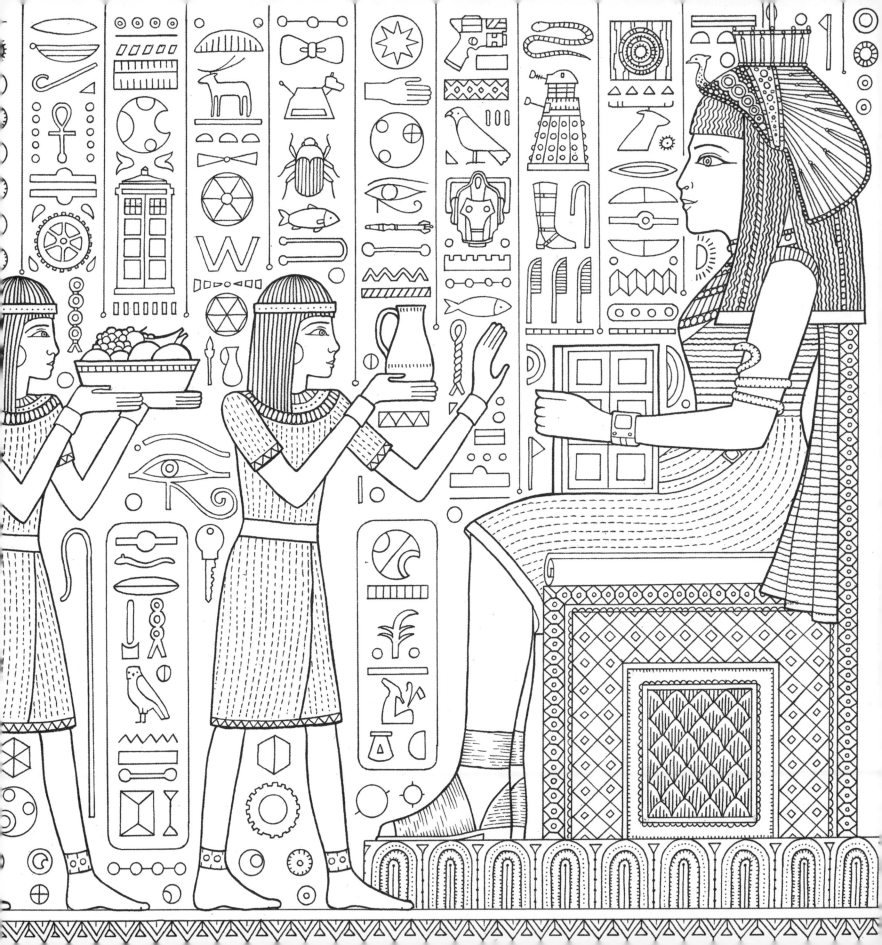

102 AD

I return to my command after one week and discover we've been playing host to Cleopatra. Who's in Egypt. And dead!

Roman Commander, 'The Pandorica Opens', 2010

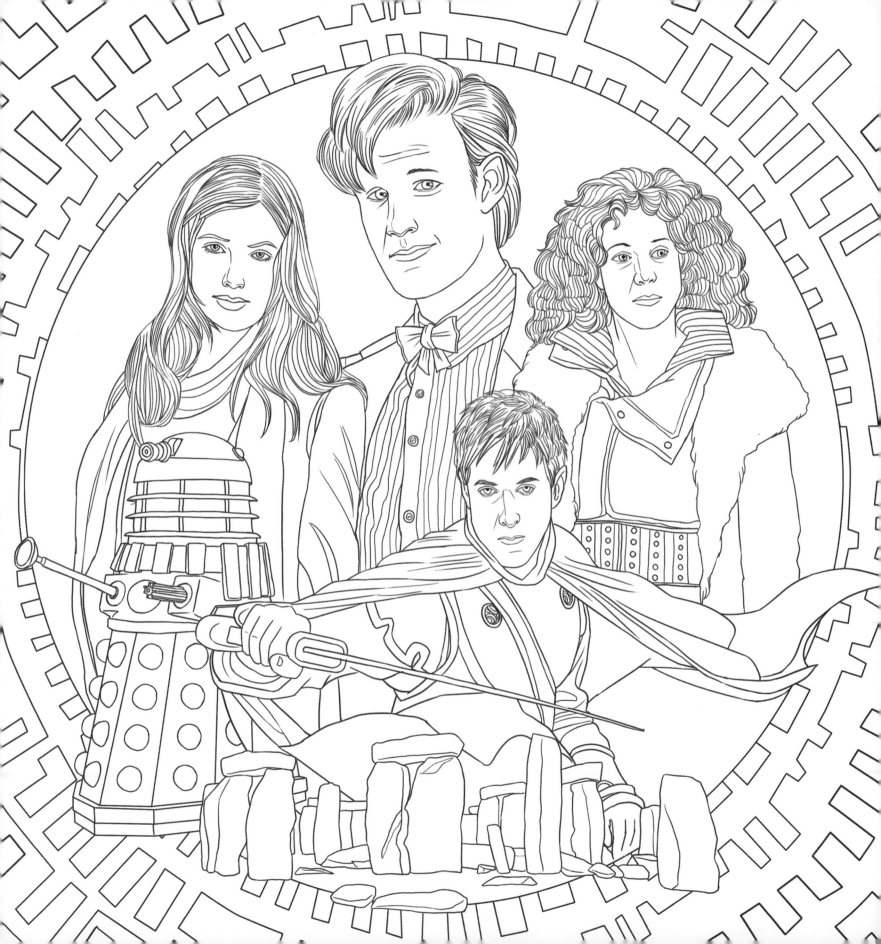

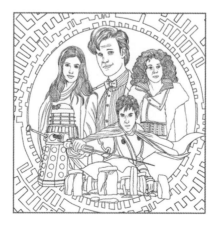

102 AD

Hello, Stonehenge! Who takes the Pandorica, takes the universe!

The Eleventh Doctor, 'The Pandorica Opens', 2010

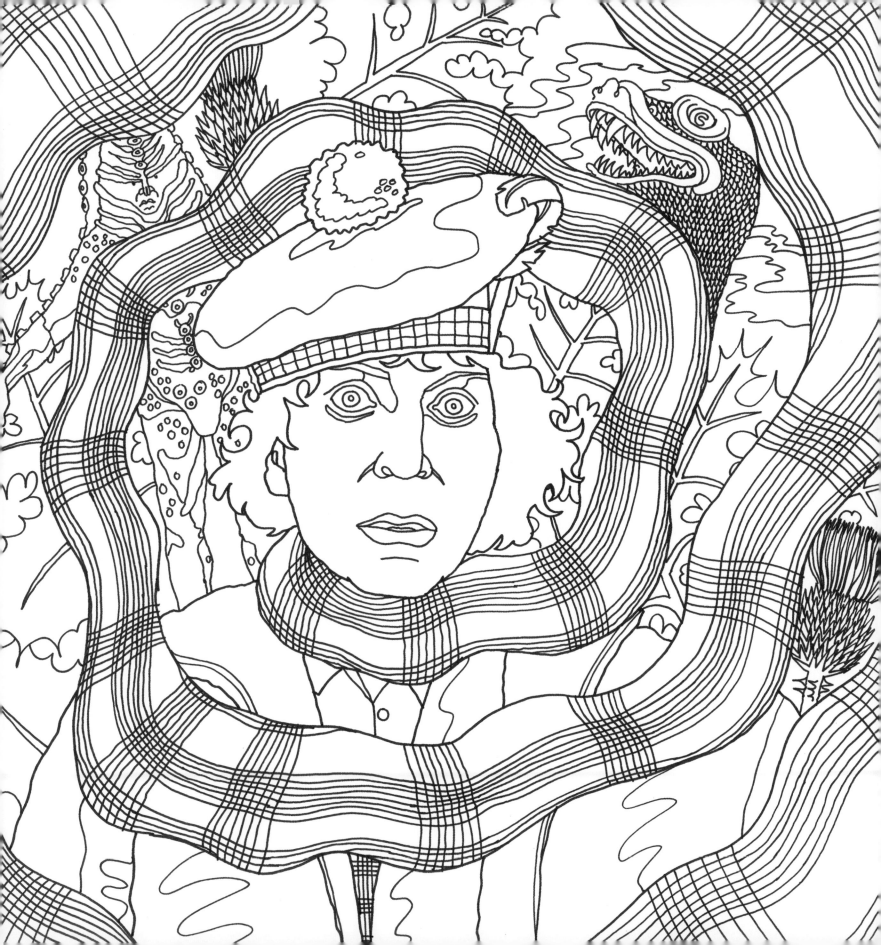

476 AD

We have reason to believe there's something rather unusual in the loch . . .

The Brigadier, 'Terror of the Zygons', 1975

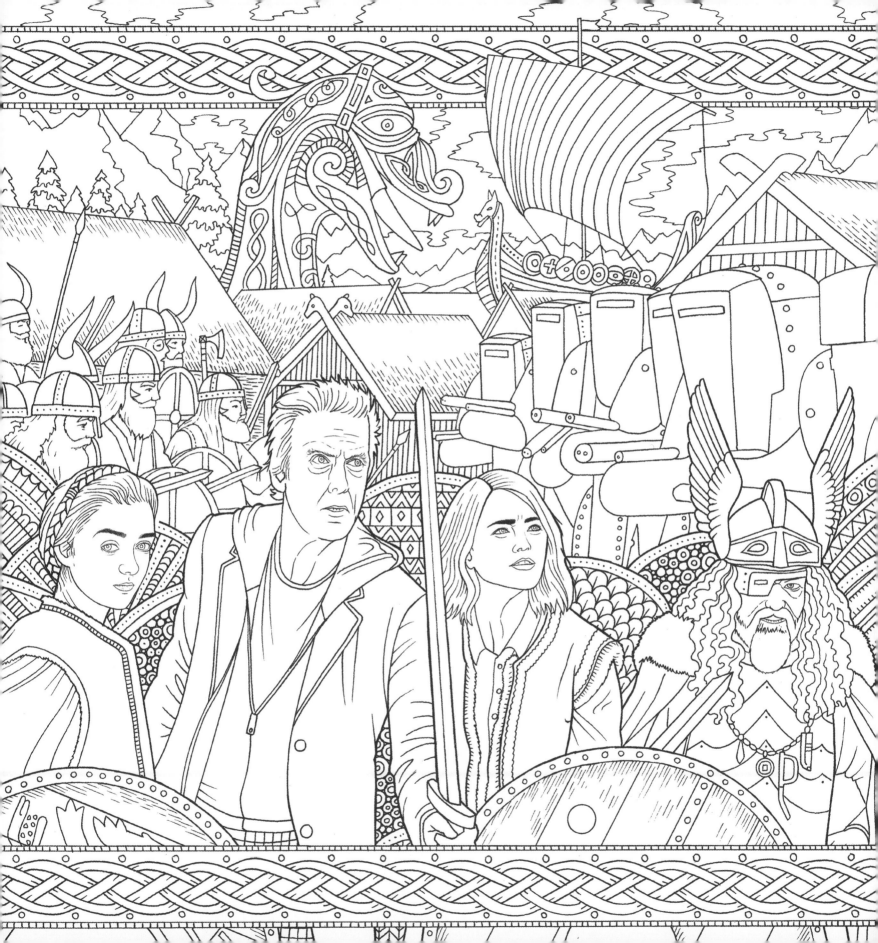

800 AD

Fly like a bird, run like a nose. That's probably a Viking saying. I haven't checked that.

The Twelfth Doctor, 'The Girl Who Died', 2015

1066 AD

He loses the Battle of Hastings to William the Conqueror. Well, at least that's what the history books said happened . . .

The First Doctor, 'A Battle of Wits', 1965

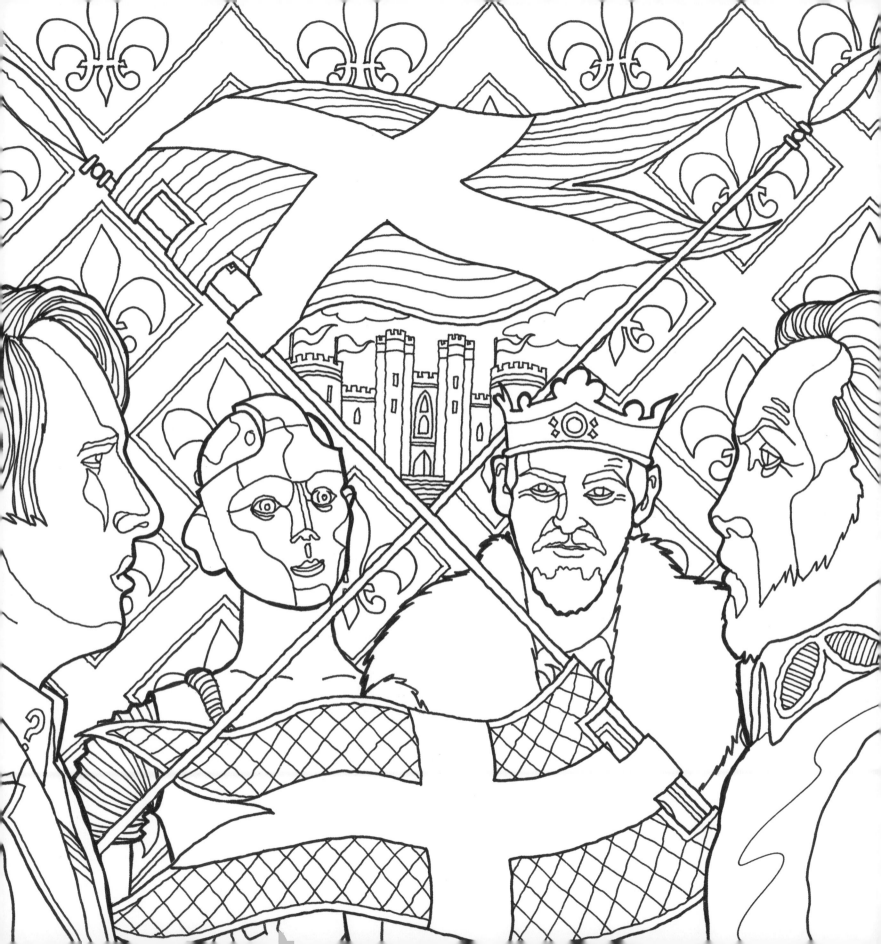

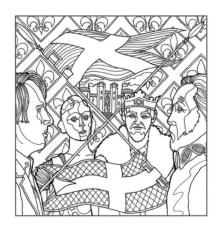

1215 AD

Medieval misfits! Don't think you've won yet, Doctor . . .

The Master, 'The King's Demons', 1983

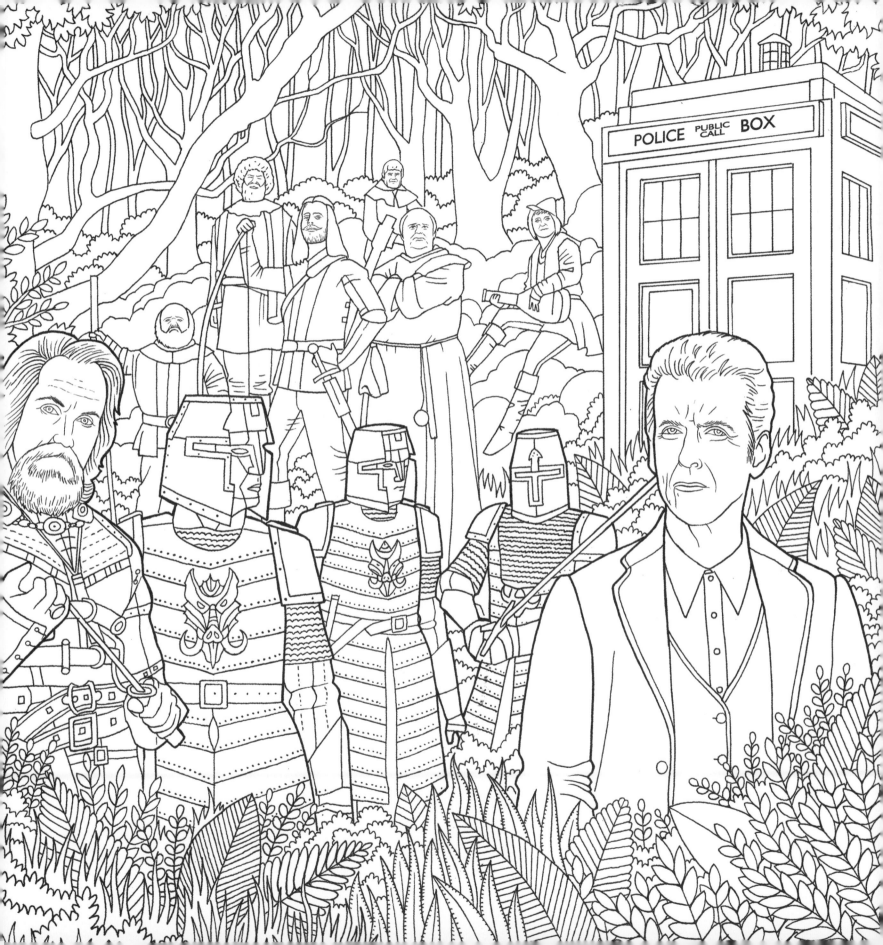

1228 AD

Long-haired ninny versus robot killer knights? I know where I'd put my money.

The Twelfth Doctor, 'Robot of Sherwood', 2014

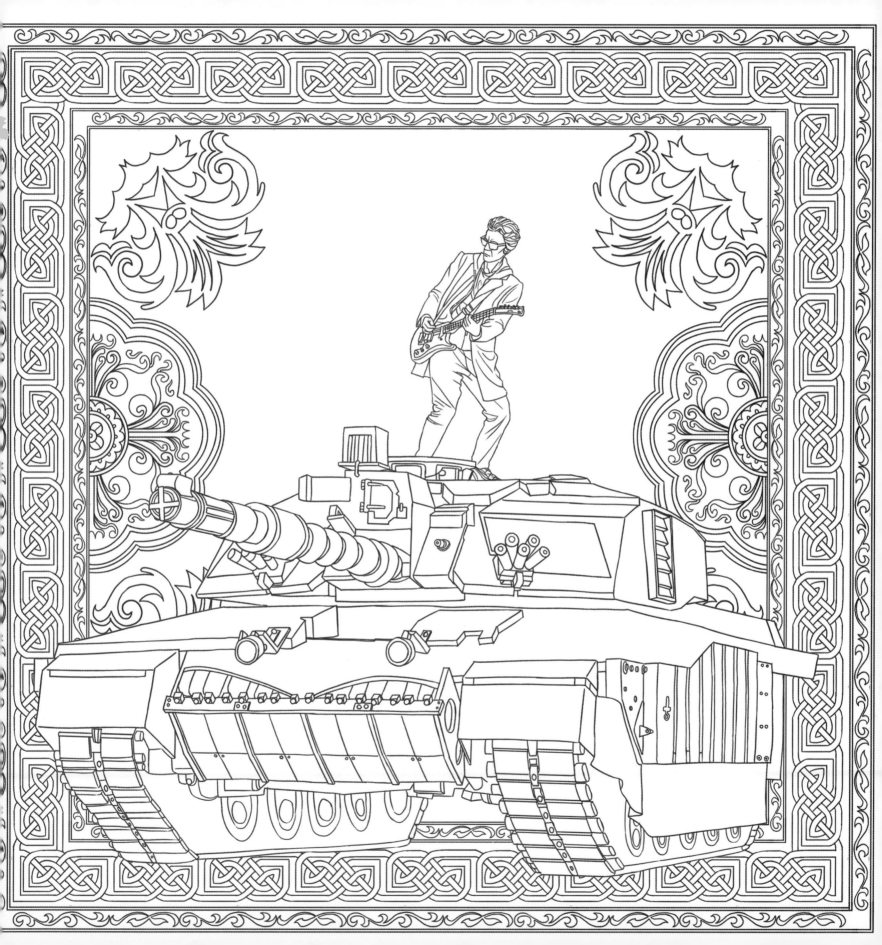

1300 AD

I spent all day yesterday in a bow tie, the day before in a long scarf. It's my party, and all of me is invited.

The Twelfth Doctor, 'The Magician's Apprentice', 2015

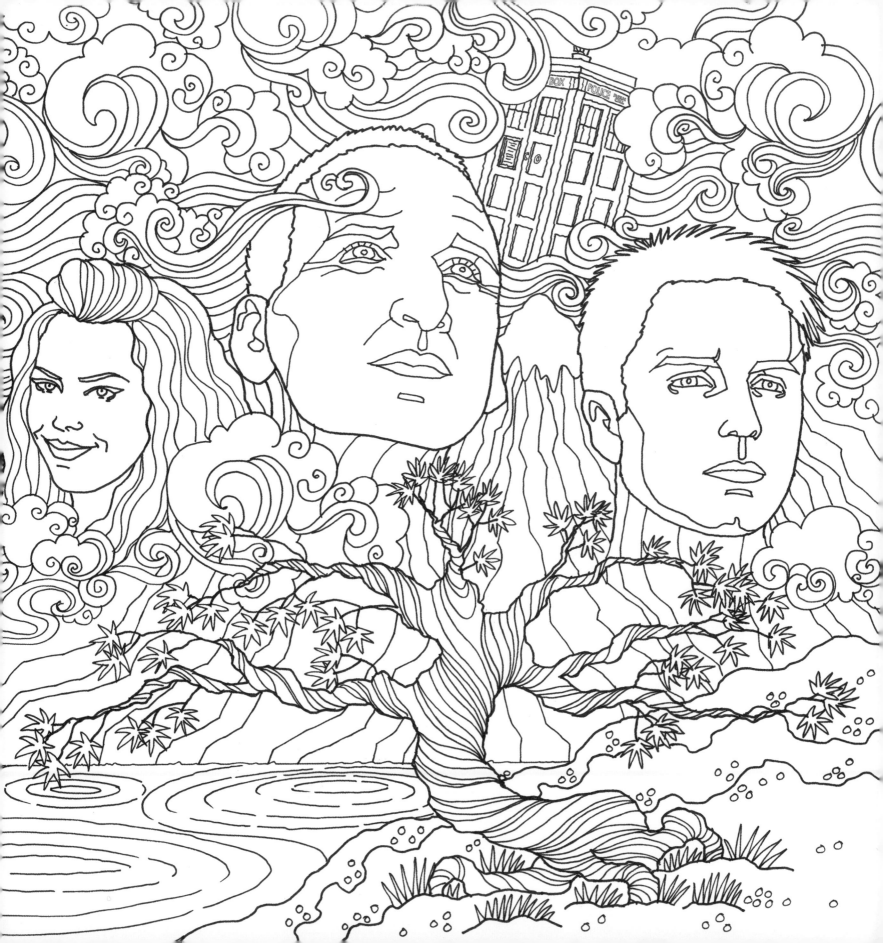

1336 AD

We'd just left Raxacoricofallapatorius. Then we went to Kyoto. That's right – Japan in 1336!

The Ninth Doctor, 'Bad Wolf', 2005

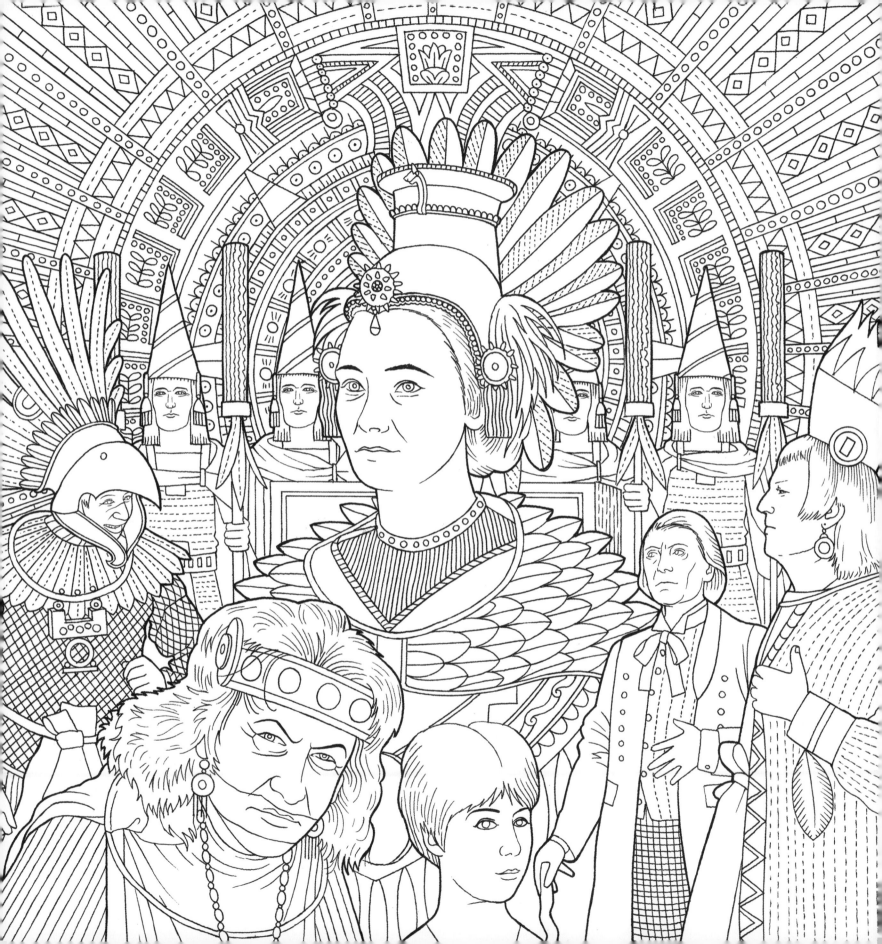

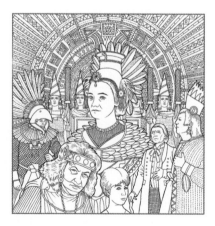

1430 AD

What's the point of travelling through time and space if we can't change anything?

Barbara Wright, 'The Aztecs', 1964

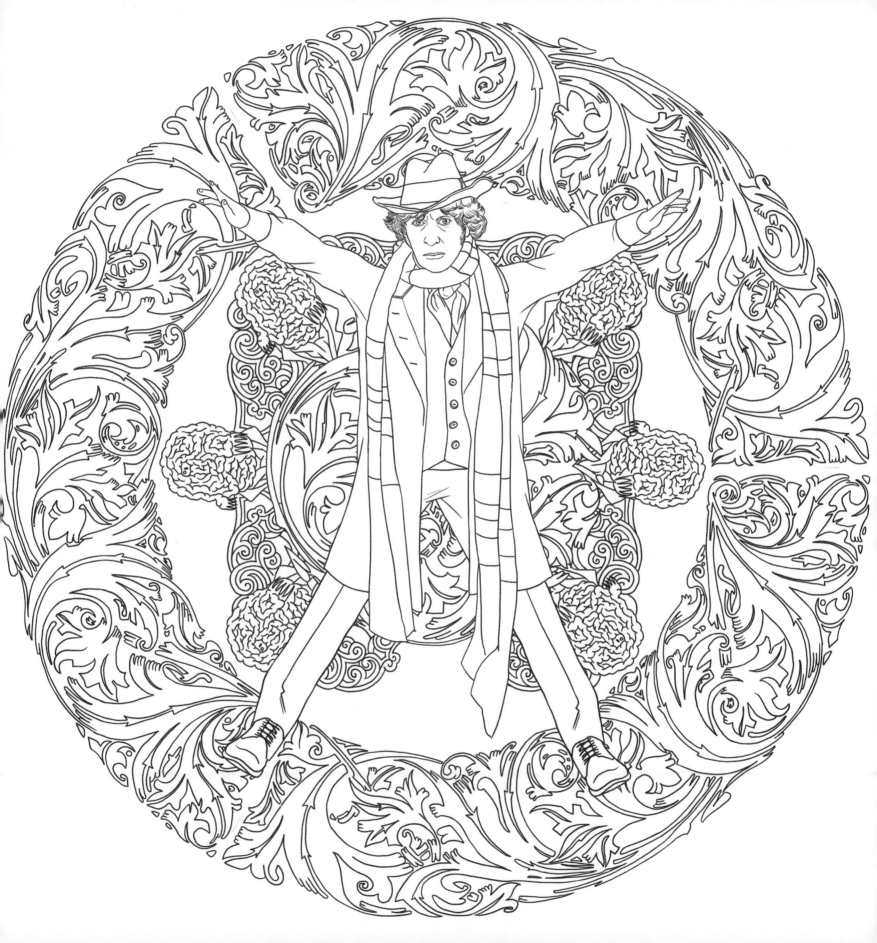

1505 AD

Is that all you can say? No eyebrows? We're talking about the Mona Lisa!

The Fourth Doctor, 'City of Death', 1979

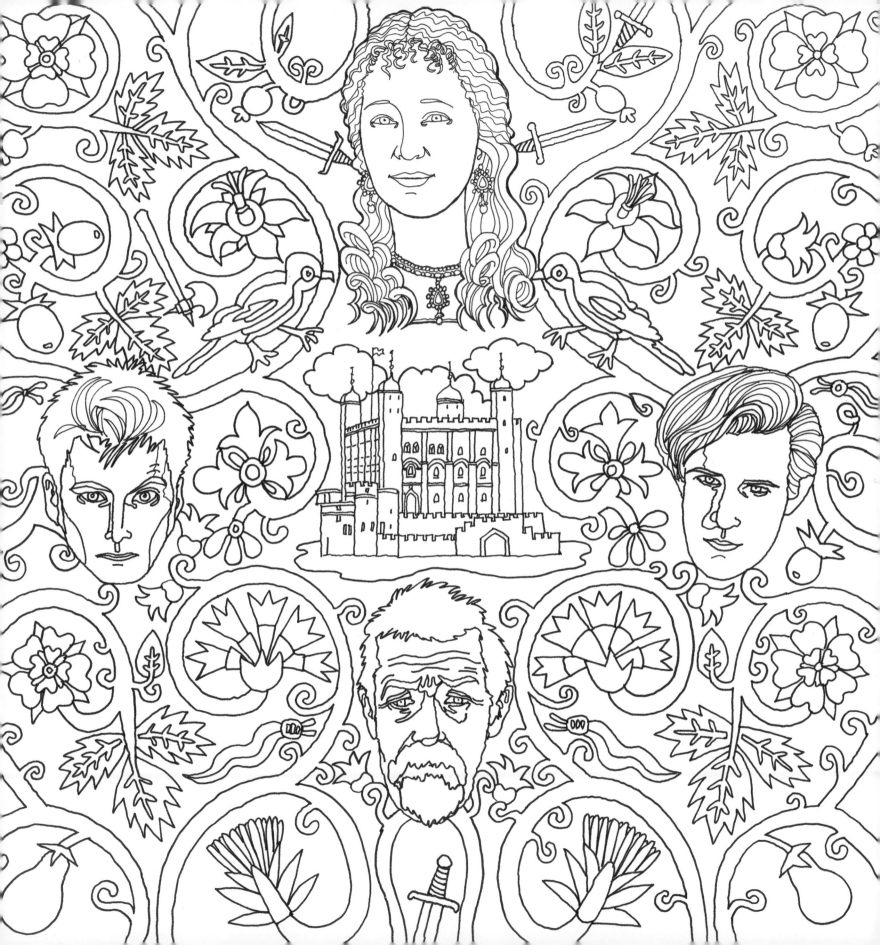

1562 AD

Tell me, Doctor, why I'm wasting my time on you. I have wars to plan.

Elizabeth I, 'The Day of the Doctor', 2013

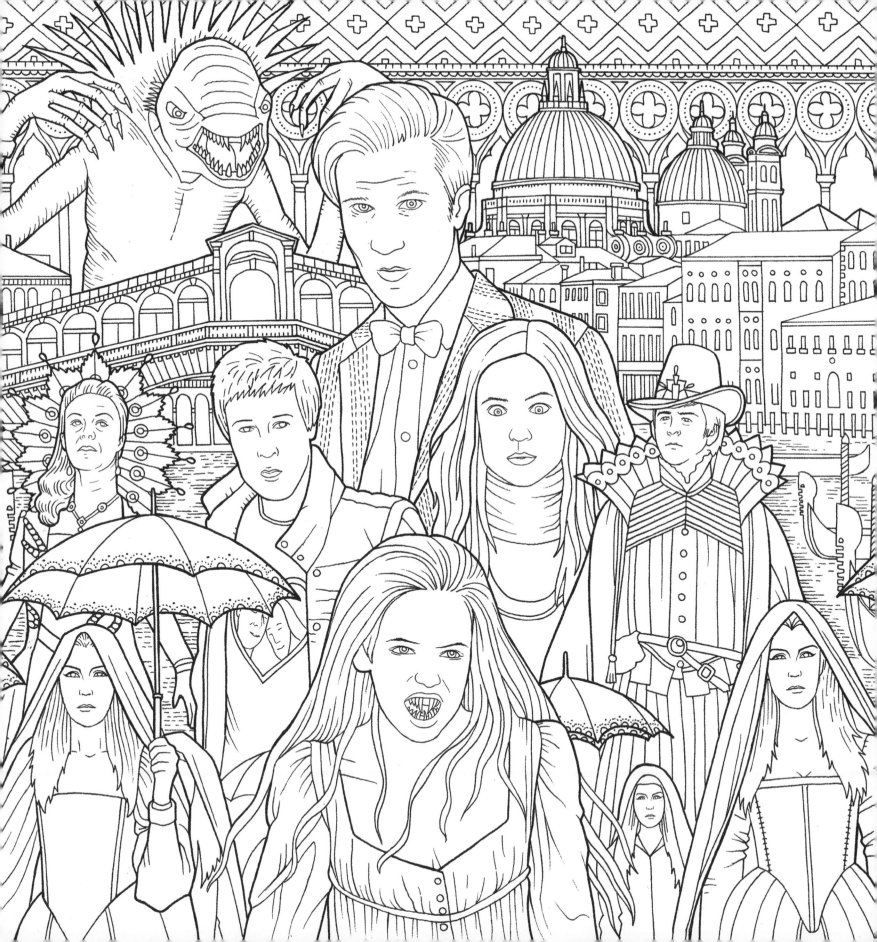

1580 AD

One city to save an entire species. Was that so much to ask?

Rosanna Calvierri, 'The Vampires of Venice', 2010

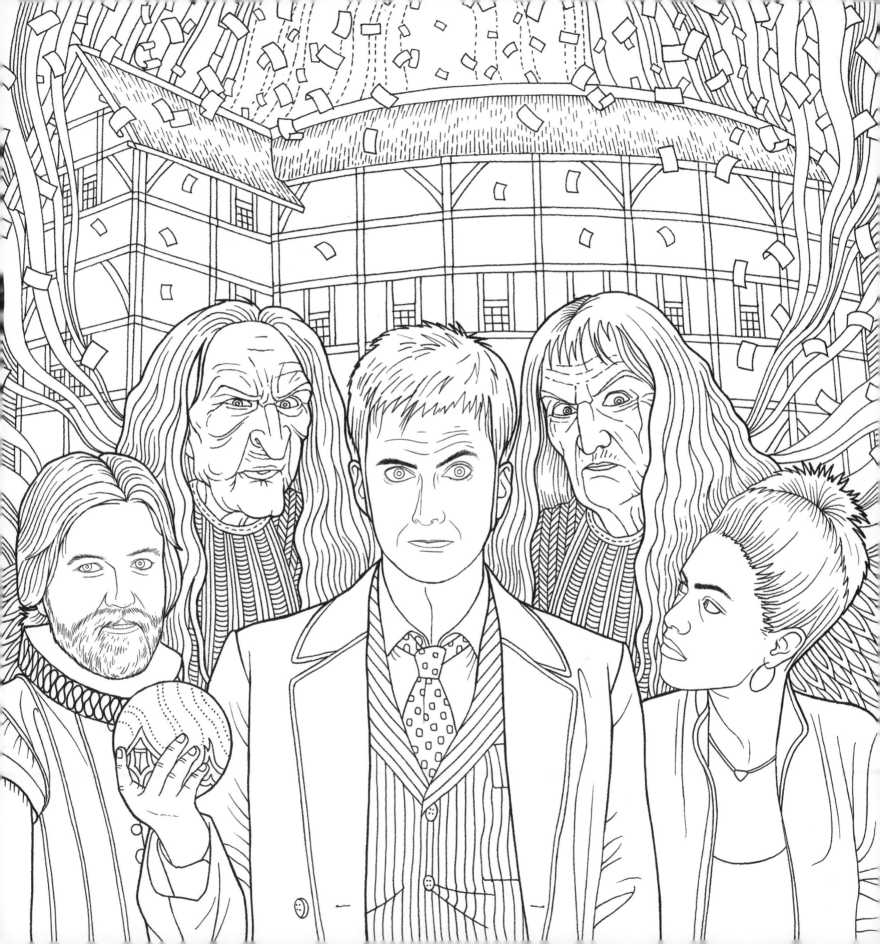

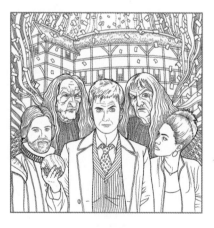

1599 AD

It made me question everything. The futility of this fleeting existence. To be or not to be? Oh, that's quite good.

William Shakespeare, 'The Shakespeare Code', 2007

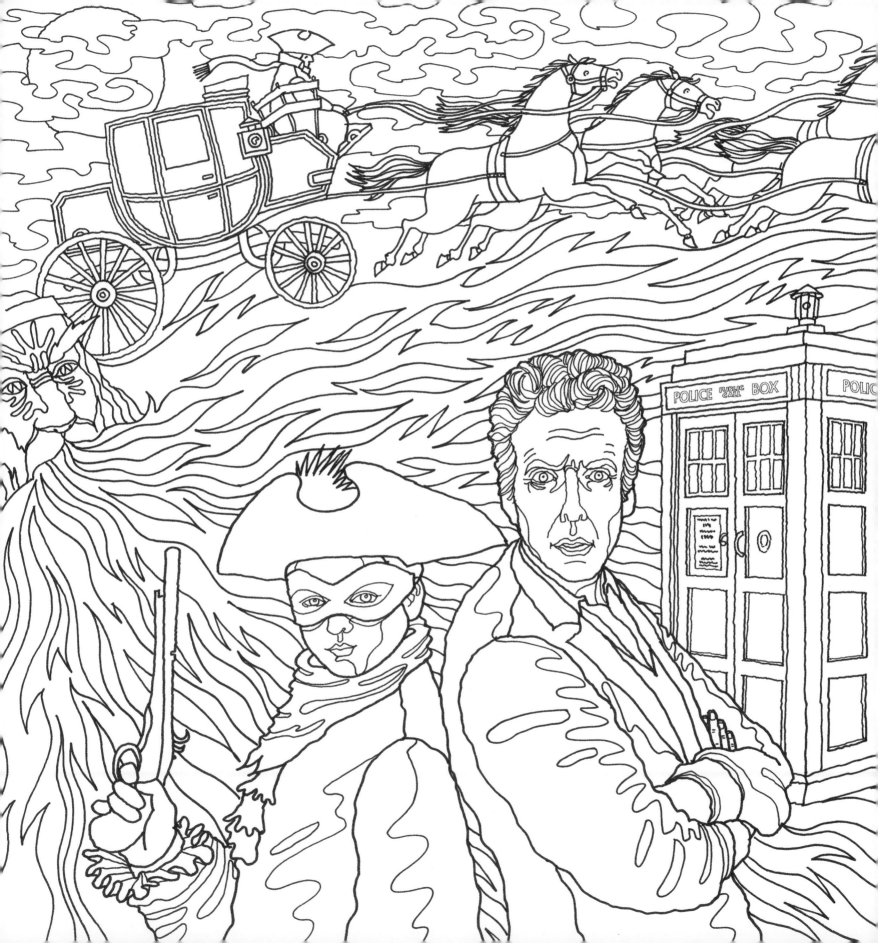

1651 AD

You gad about while I trudge through the centuries, day by day, hour by hour. Do you ever think or care what happens after you've flown away?

Me, 'The Woman Who Lived', 2015

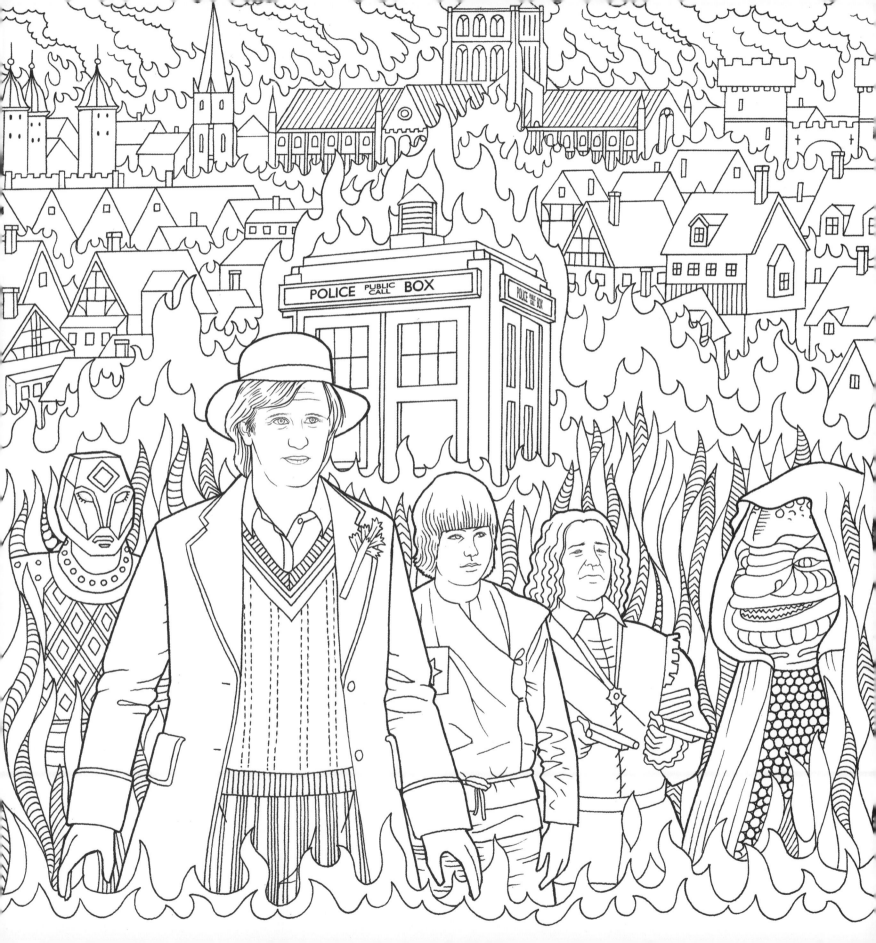

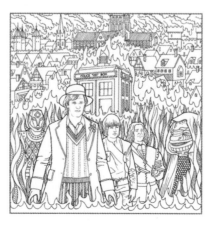

1666 AD

I have a sneaking suspicion this fire should be allowed to run its course.

The Fifth Doctor, 'The Visitation', 1982

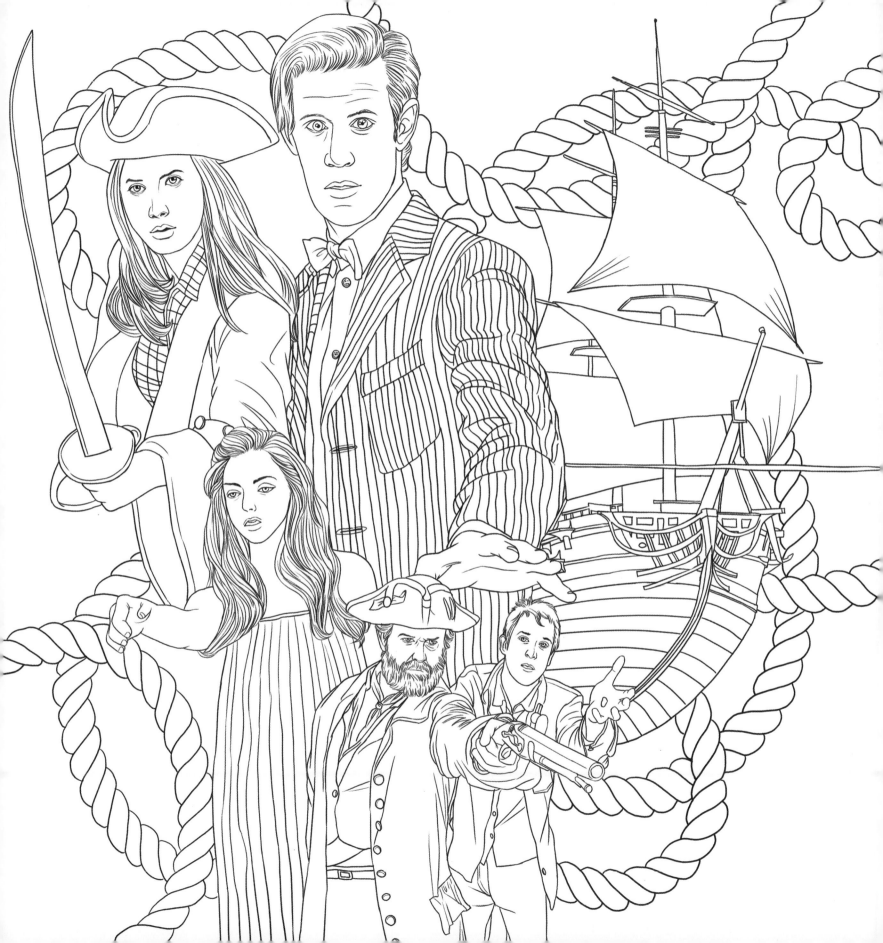

1699 AD

Yo-ho-ho! Or does nobody actually say that?

The Eleventh Doctor, 'The Curse of the Black Spot', 2011

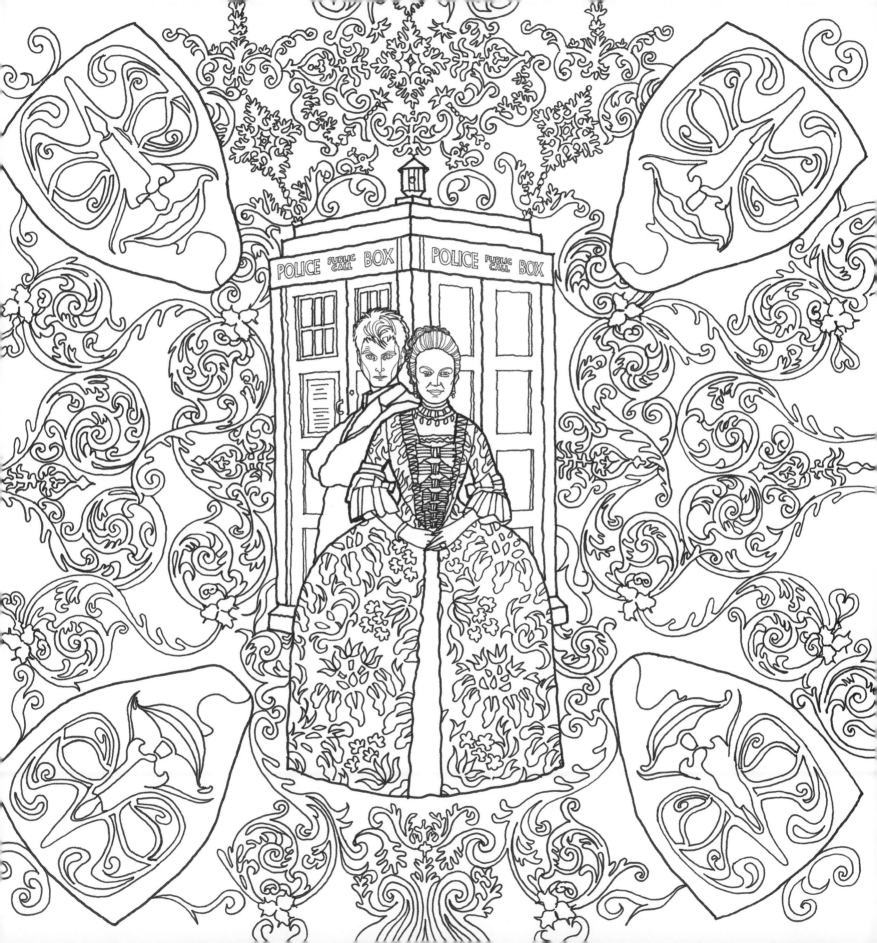

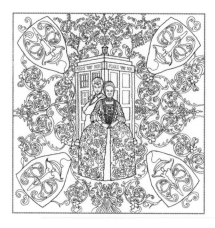

1742 AD

There is a man coming to Versailles. He has watched over me my whole life and he will not desert me tonight.

Madame de Pompadour, 'The Girl in the Fireplace', 2006

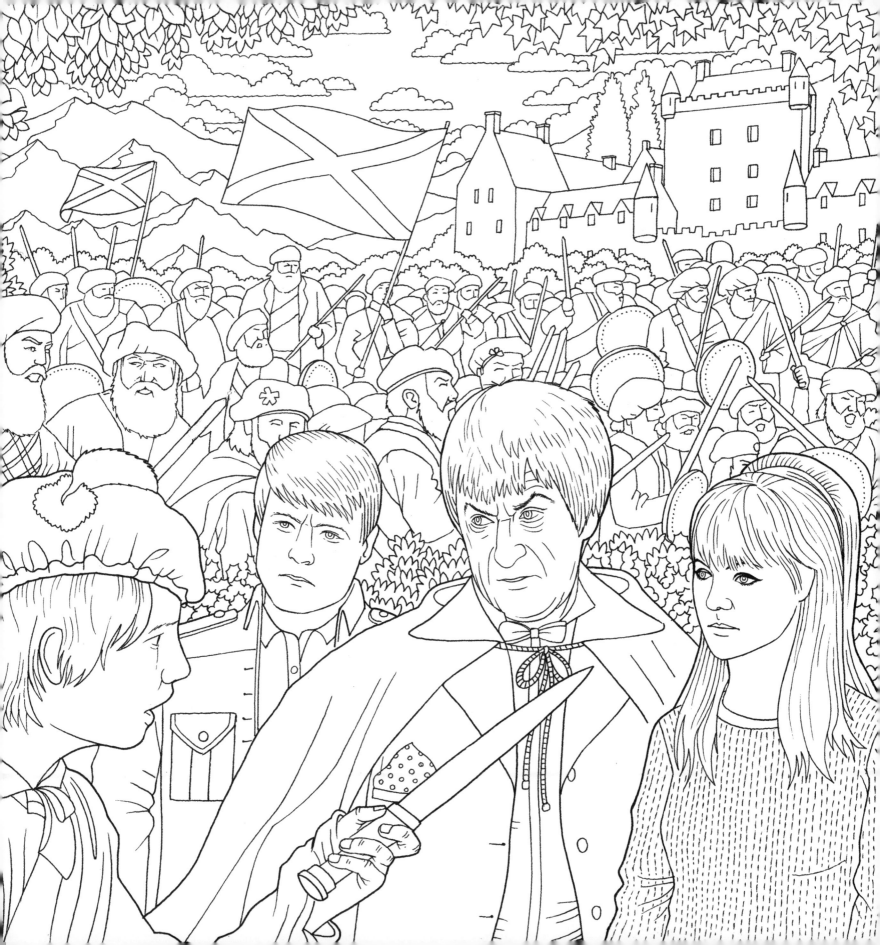

1746 AD

I'm just beginning to enjoy myself. Down with King George!

The Second Doctor, 'The Highlanders', 1966

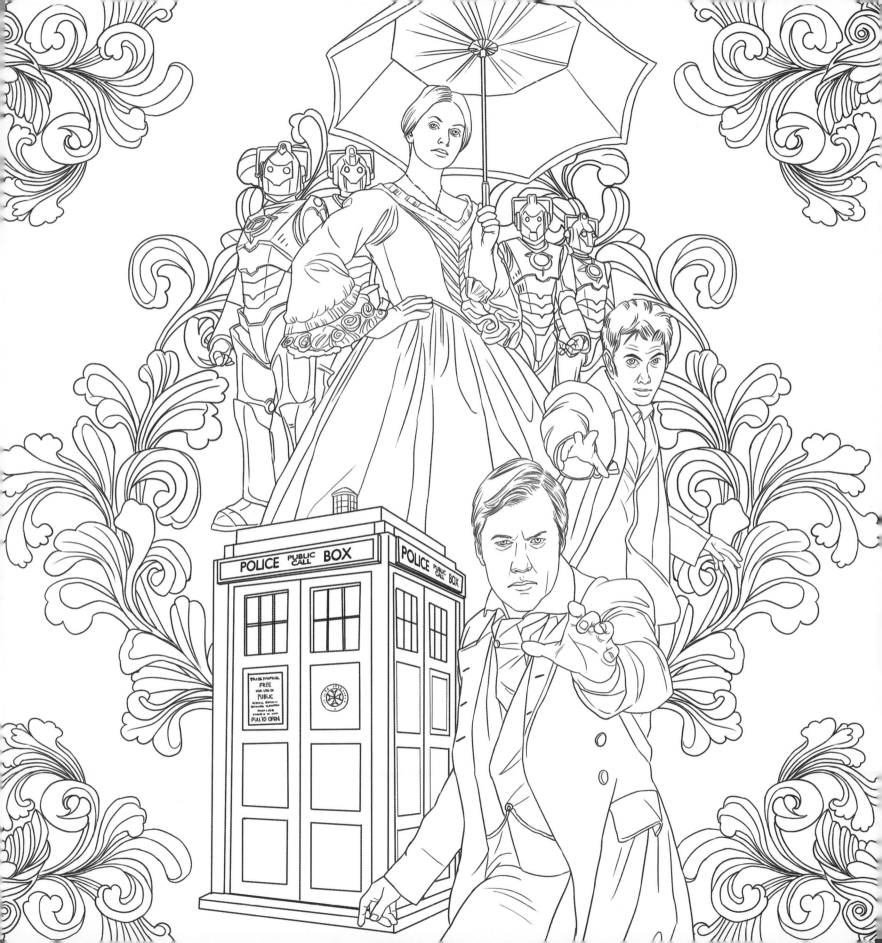

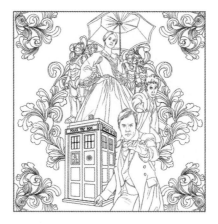

1851 AD

T - A - R - D - I - S. It stands for Tethered Aerial Release Developed in Style!

Jackson Lake, 'The Next Doctor', 2008

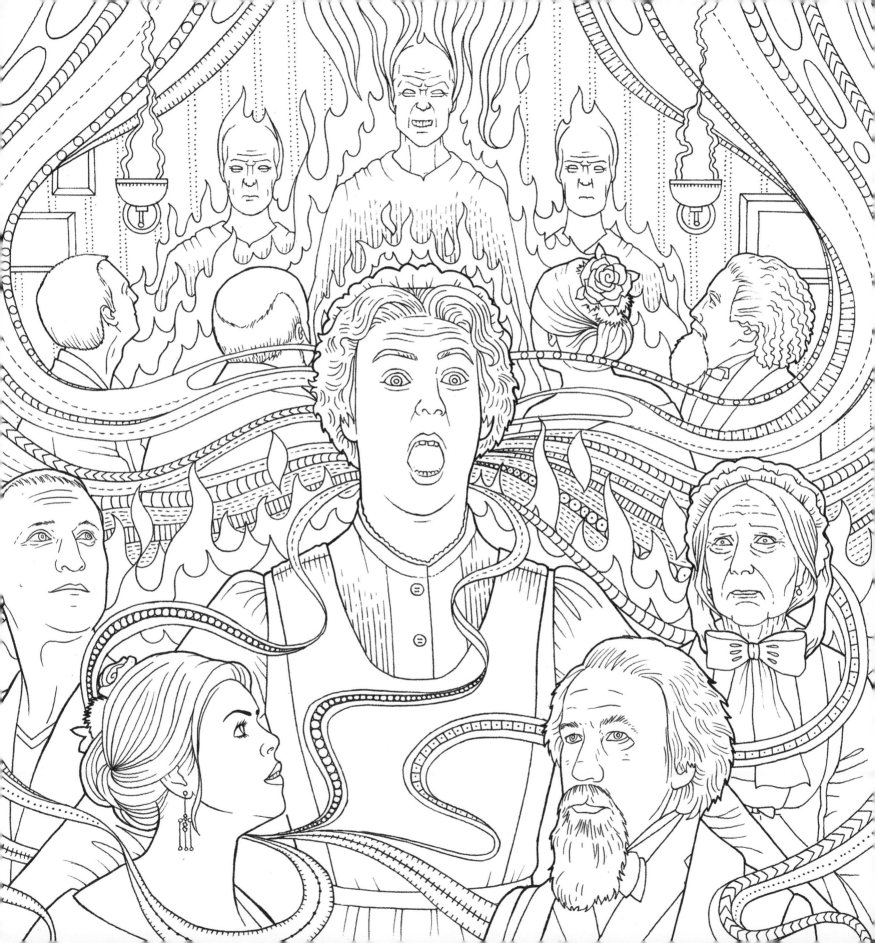

1869 AD

I don't wish to impose on you, but I must ask you . . . My books, Doctor. Do they last?

Charles Dickens, 'The Unquiet Dead', 2005

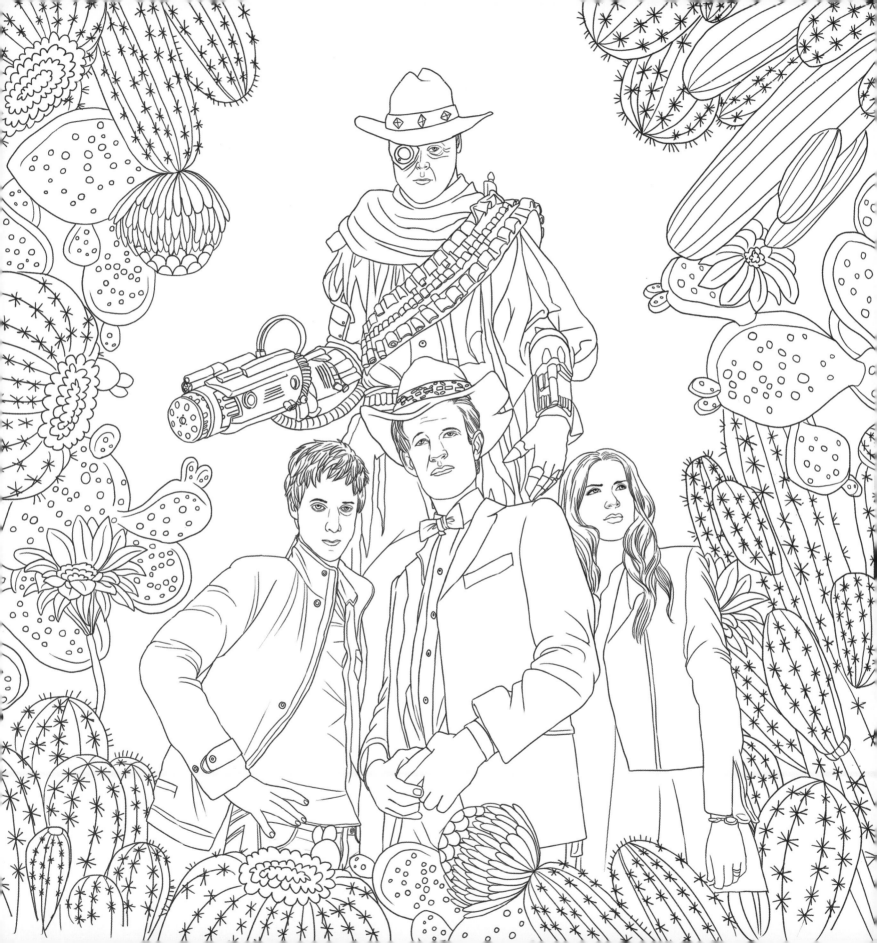

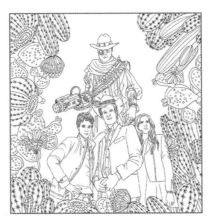

1870 AD

I see 'keep out' signs as suggestions more than actual orders. Like 'dry clean only'.

The Eleventh Doctor, 'A Town Called Mercy', 2012

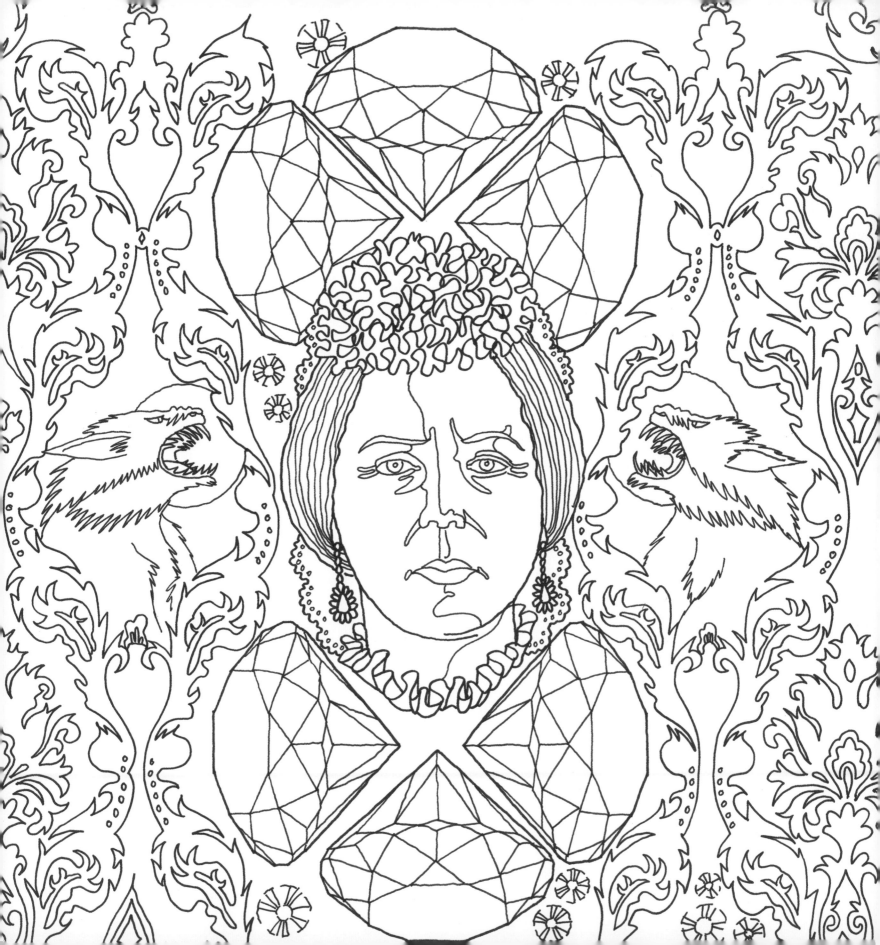

1879 AD

You want weapons? We're in a library! Books! The best weapons in the world!

The Tenth Doctor, 'Tooth and Claw', 2006

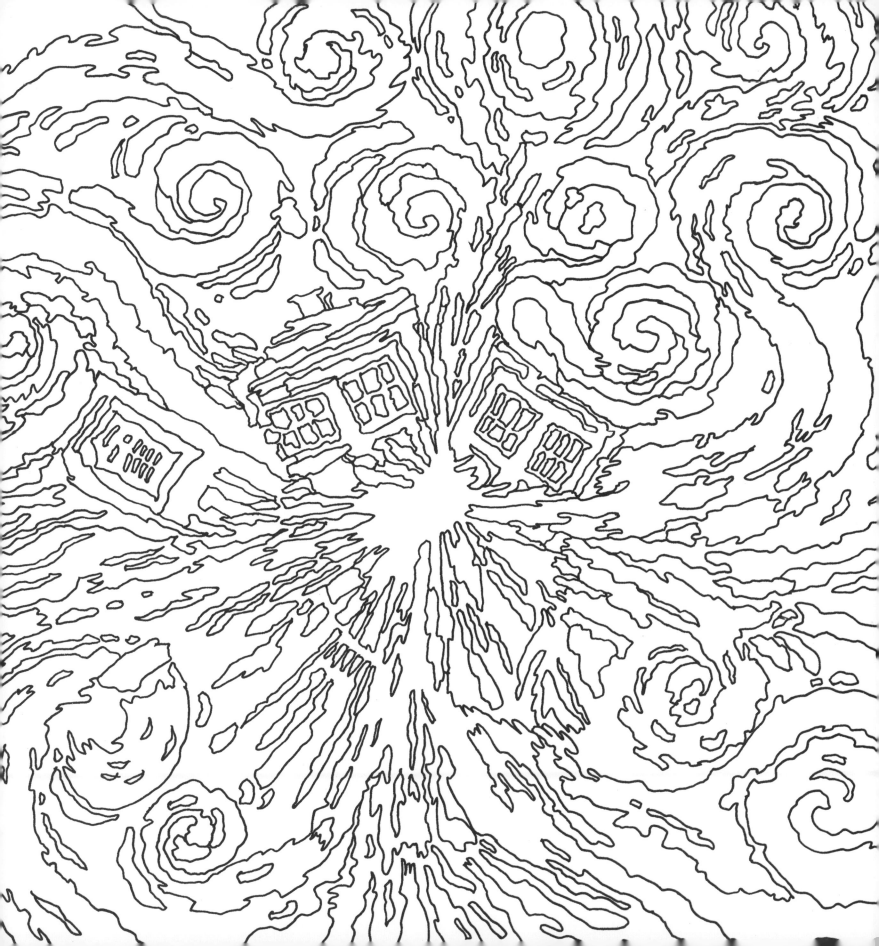

1890 AD

You see how they roar their light. Everywhere we look, the complex magic of nature blazes before our eyes.

Vincent Van Gogh, 'Vincent and the Doctor', 2010

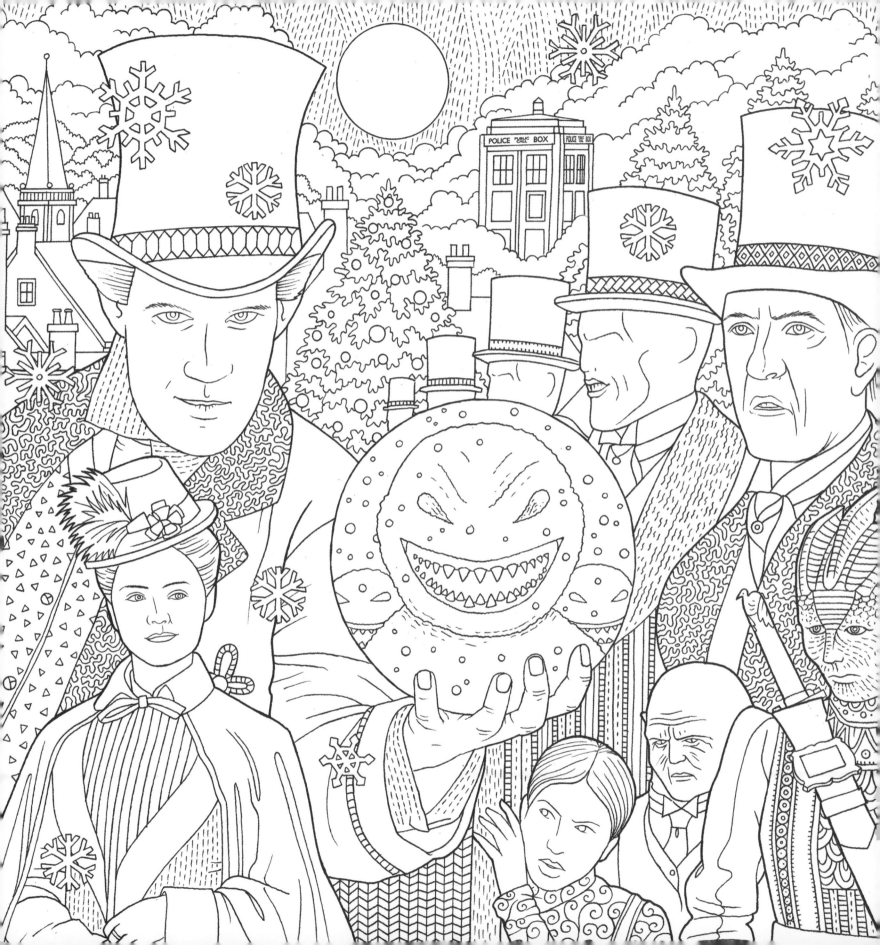

1892 AD

Run. Run, you clever boy, and remember.

Clara Oswald, 'The Snowmen', 2012

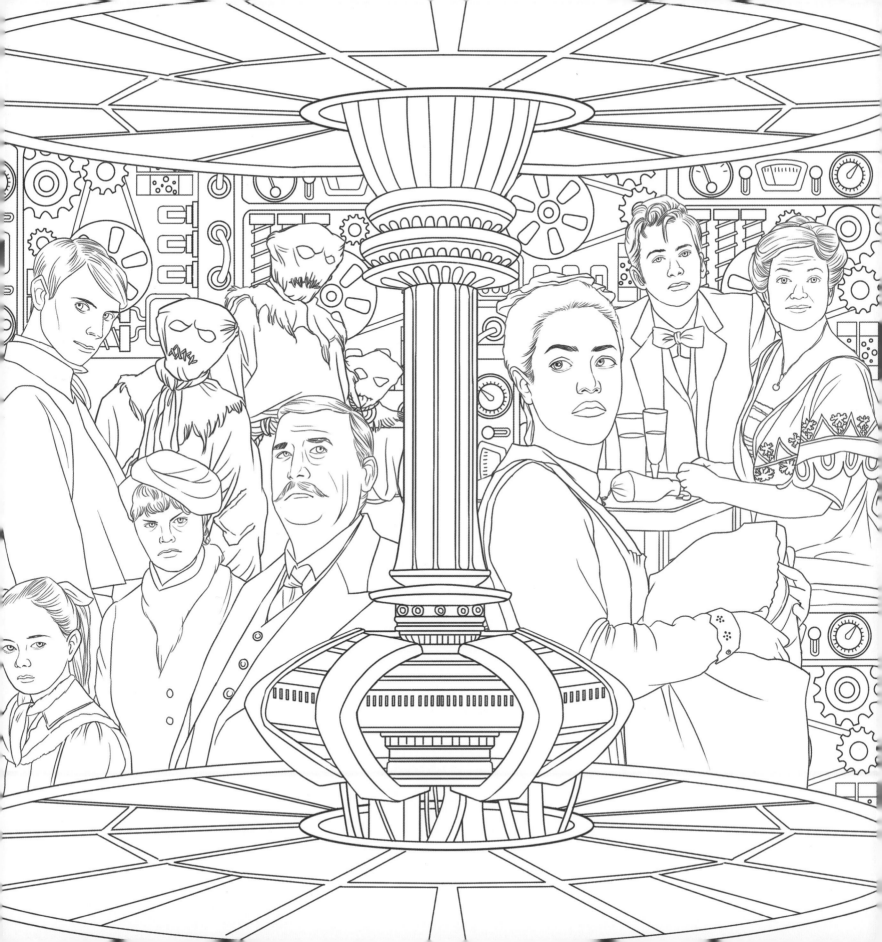

1913 AD

He's ancient and forever. He burns at the centre of time and can see the turn of the universe. And . . . he's wonderful.

Tim Latimer, 'The Family of Blood', 2007

1926 AD

Turns out we are in the middle of a murder mystery. One of yours, Dame Agatha.

The Tenth Doctor, 'The Unicorn and the Wasp', 2008

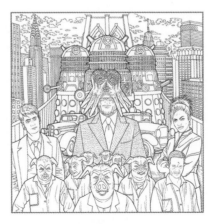

1930 AD

I've always wanted to go to New York. I mean the real New York, not the new, new, new, new, new one.

Martha Jones, 'Daleks in Manhattan', 2007

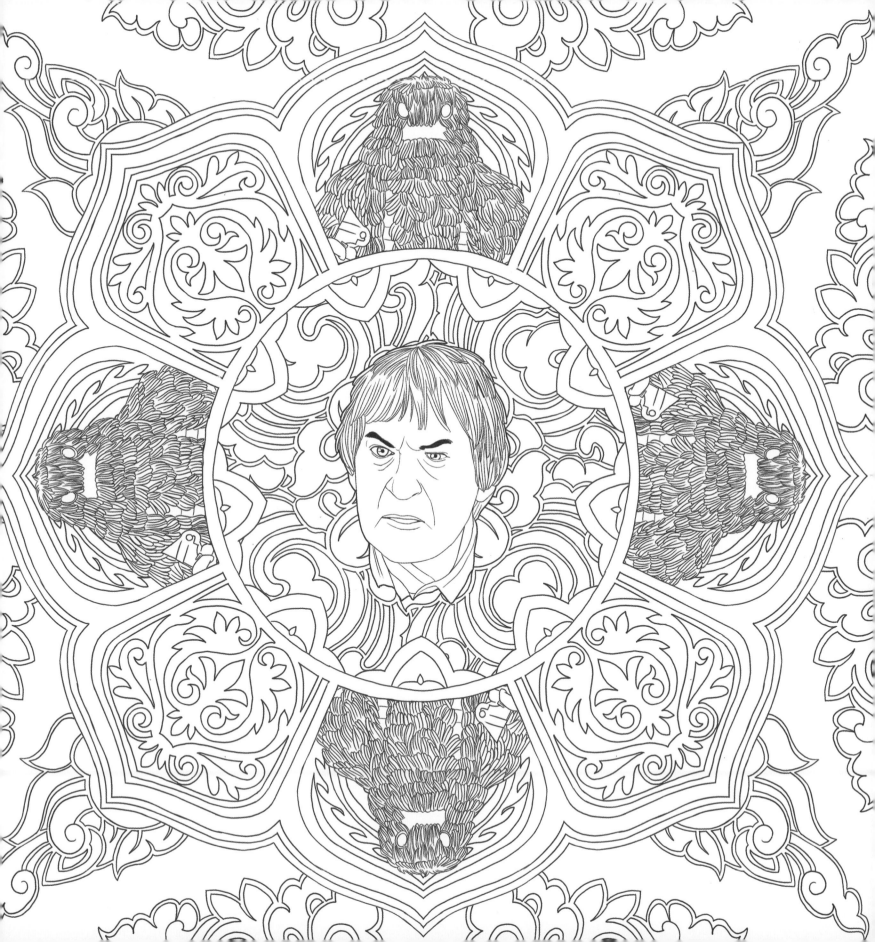

1935 AD

I don't like it. There's something happening on this mountain. I can feel it.

The Second Doctor, 'The Abominable Snowmen', 1967

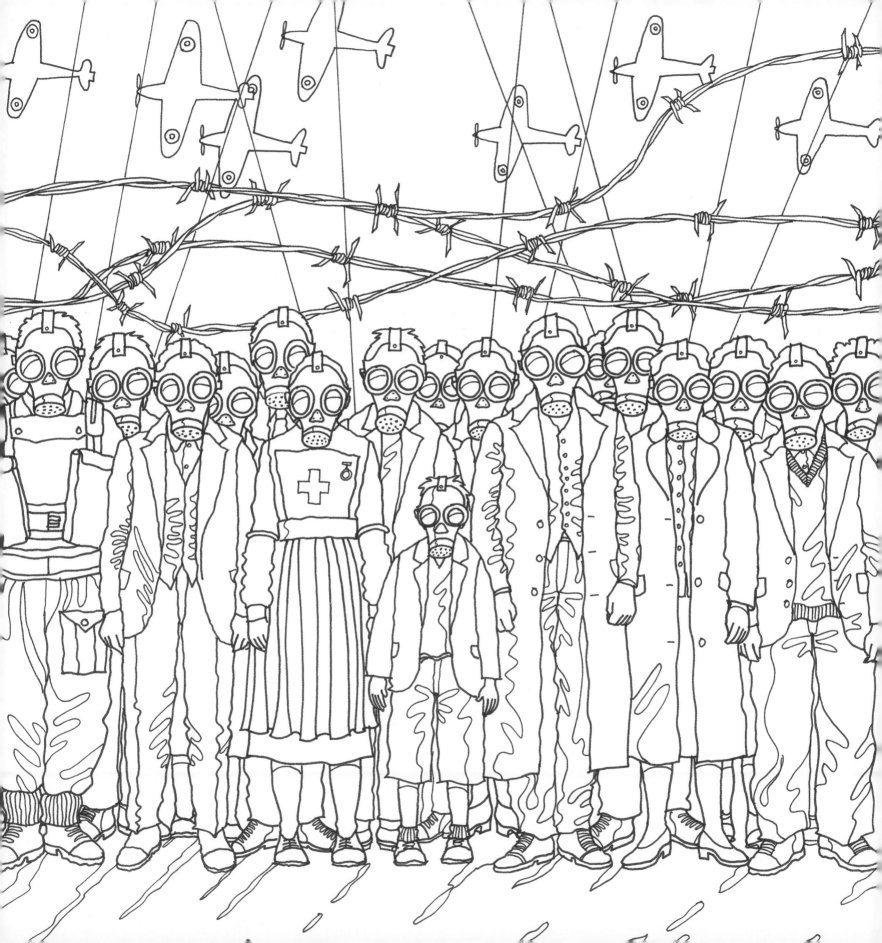

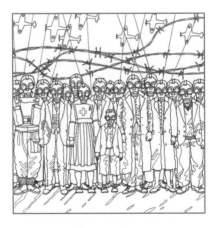

1941 AD

You're amazing, the lot of you. Don't know what you do to Hitler, but you frighten the hell out of me.

The Ninth Doctor, 'The Empty Child', 2005

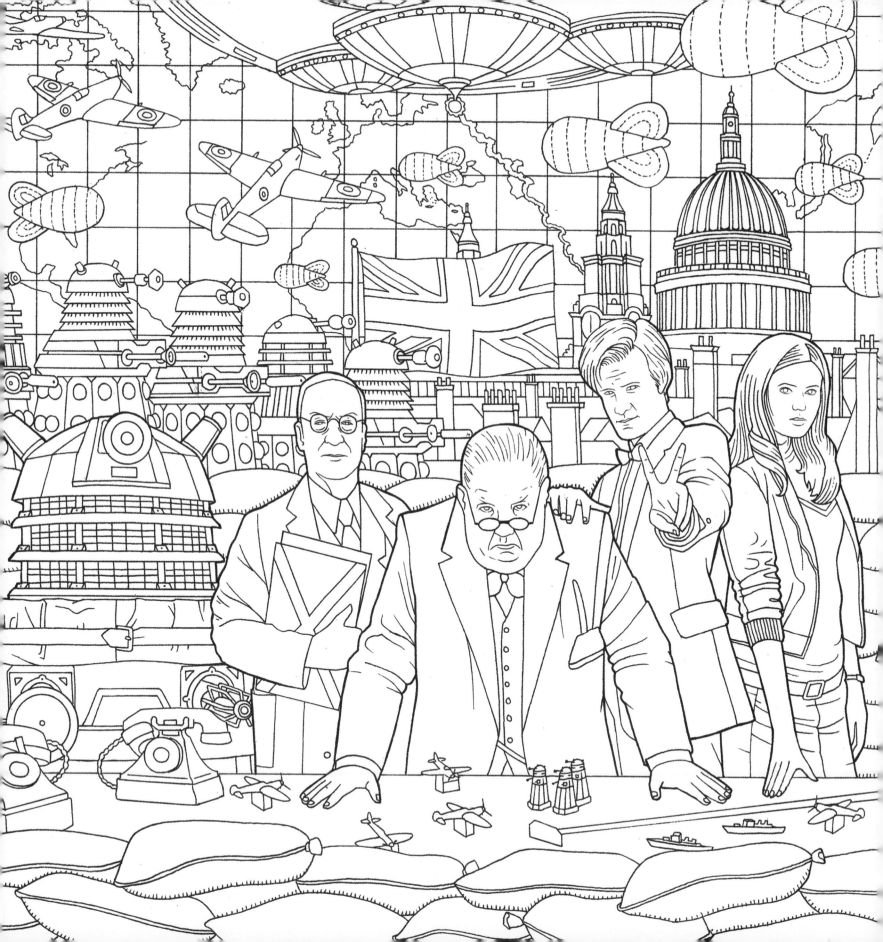

1941 AD

Think of what I could achieve with your remarkable machine, Doctor. The lives that could be saved.

Winston Churchill, 'Victory of the Daleks', 2010

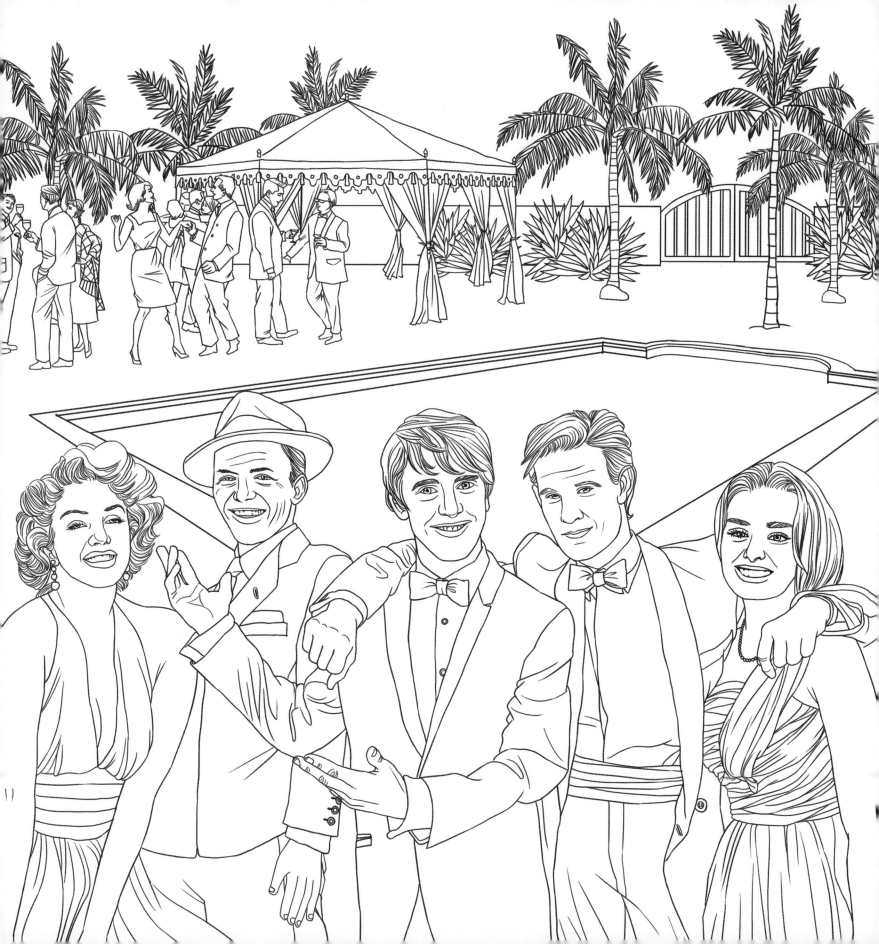

1952 AD

Guys, we've really got to go quite quickly. I just accidentally got engaged to Marilyn Monroe.

The Eleventh Doctor, 'A Christmas Carol', 2010

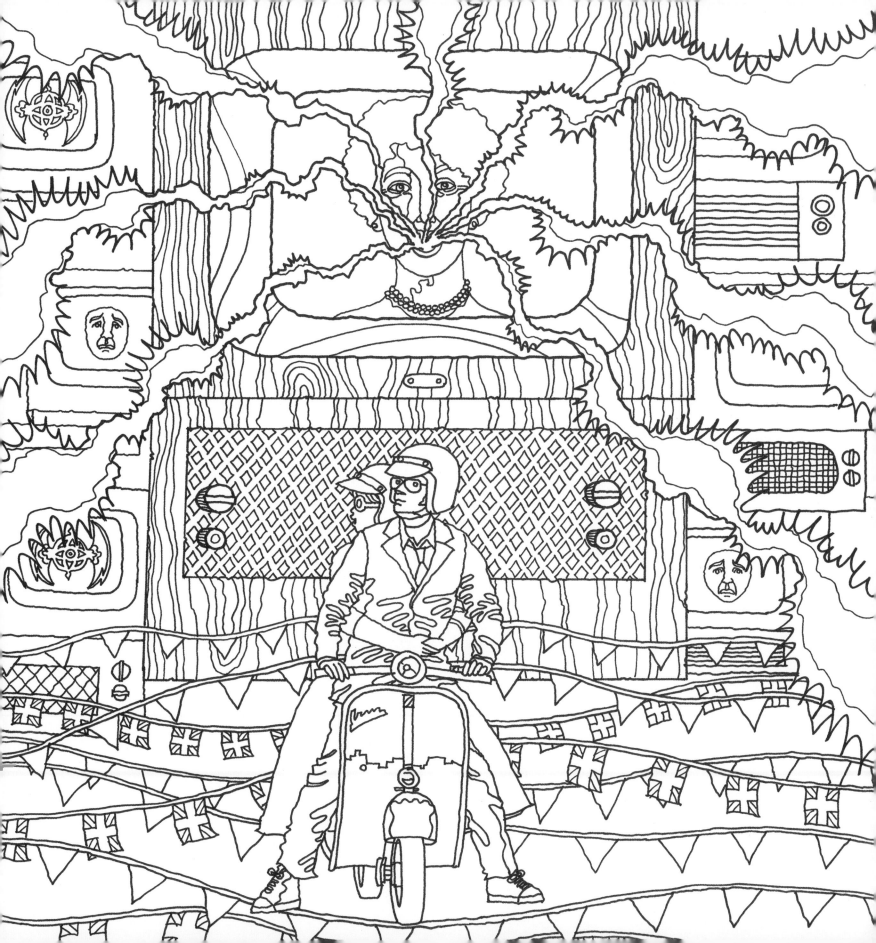

1953 AD

Kick off your shoes and enjoy the coronation. Believe me, you'll be glued to the screen.

The Wire, 'The Idiot's Lantern', 2006

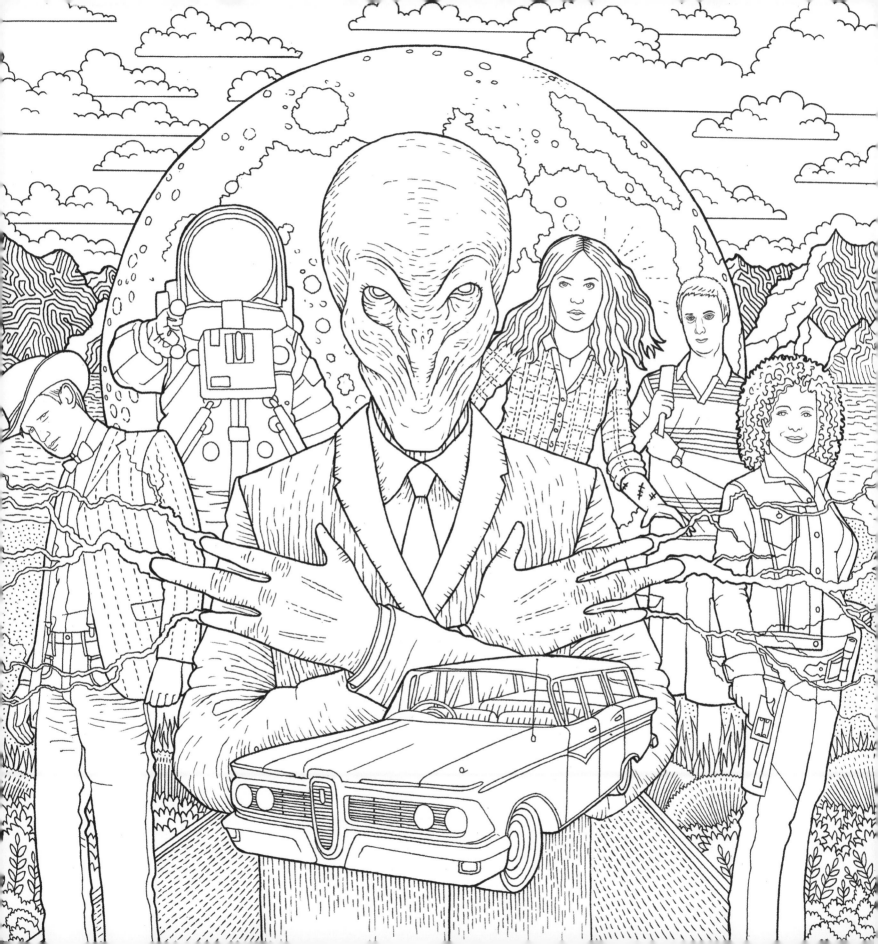

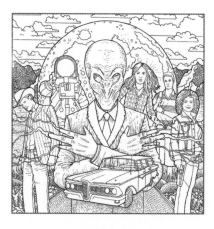

1969 AD

That's an astronaut. That's an Apollo astronaut, in a lake.

Rory Williams, 'The Impossible Astronaut', 2011

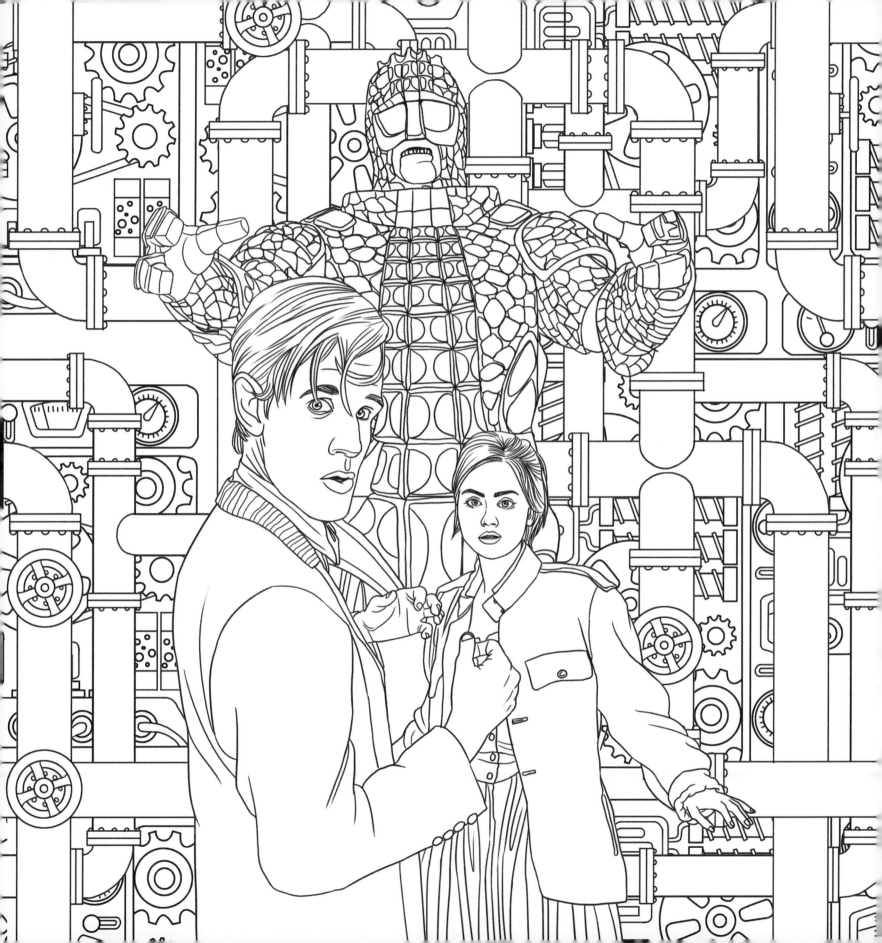

1983 AD

Hair, shoulder pads, nukes. It's the 1980s. Everything's bigger.

The Eleventh Doctor, 'Cold War', 2013

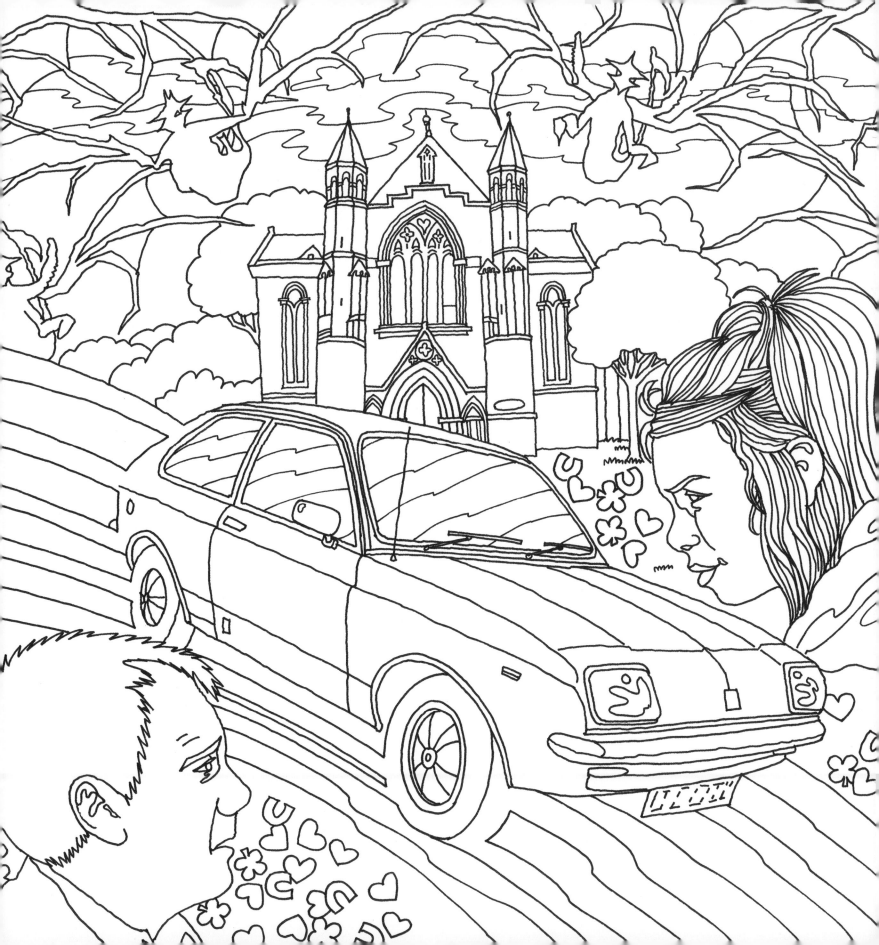

1987 AD

Peter Alan Tyler, my dad. The most wonderful man in the world. Died the seventh of November, 1987.

Rose Tyler, 'Father's Day', 2005

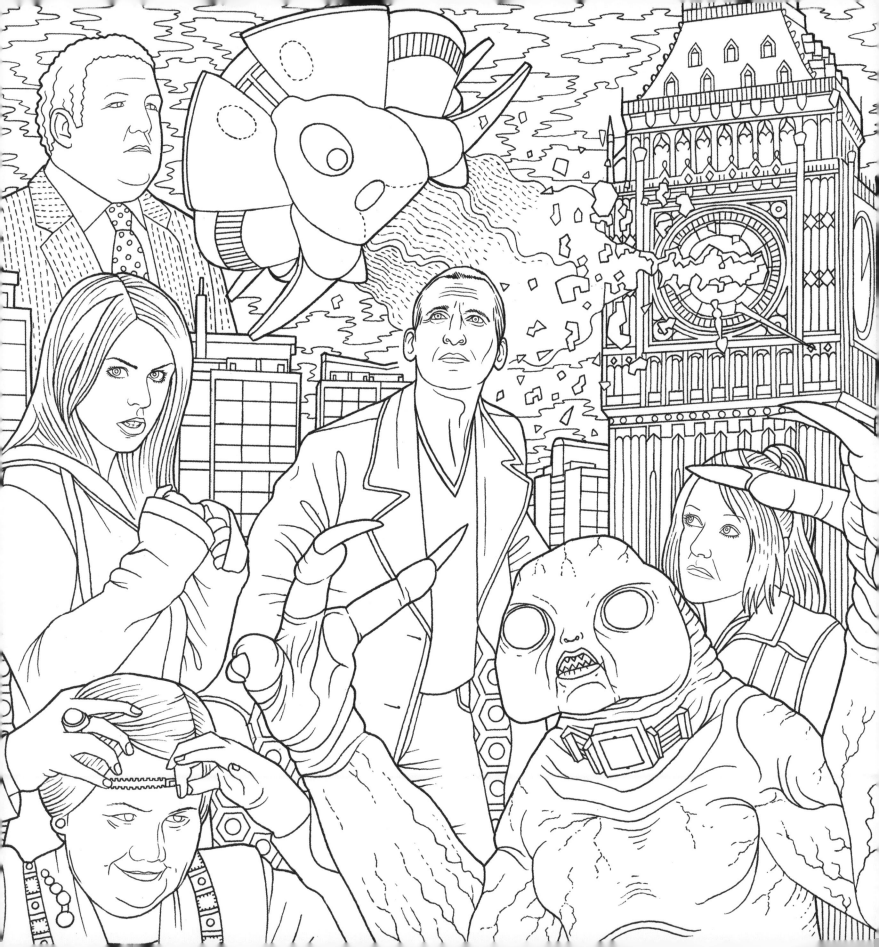

2006 AD

Nine hundred years of time and space, and I've never been slapped by someone's mother.

The Ninth Doctor, 'Aliens of London', 2005

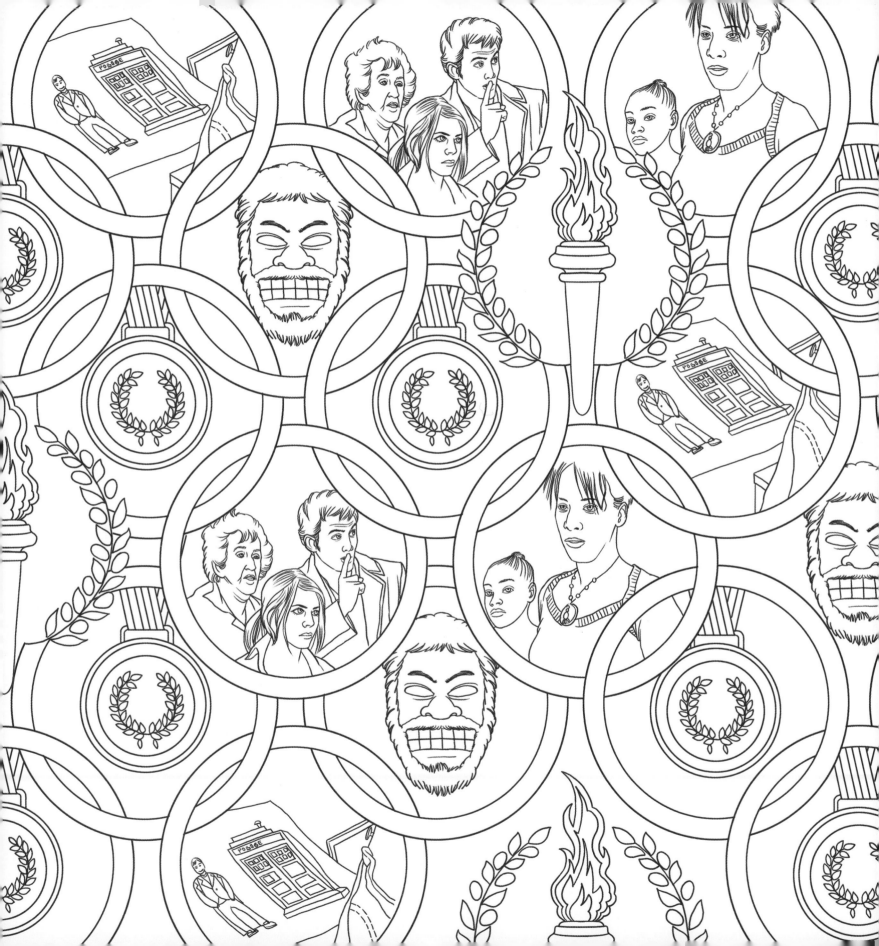

2012 AD

Tonight they'll light the Olympic flame in the stadium, and the whole world will be looking at our city.

Trish Webber, 'Fear Her', 2006